COOL SHOPS
PARIS

teNeues

Editor:	Llorenç Bonet
Photography:	Roger Casas
Introduction:	Llorenç Bonet
Copy editing:	Raquel Vicente Durán
Layout & Pre-press:	Cris Tarradas Dulcet
Translations:	Bill Bain (English), Susanne Engler (German), Michel Ficerai/Lingo Sense (French), Maurizio Siliato (Italian)

Produced by Loft Publications
www.loftpublications.com

Published by teNeues Publishing Group

teNeues Publishing Company
16 West 22nd Street, New York, NY 10010, USA
Tel.: 001-212-627-9090, Fax: 001-212-627-9511

teNeues Book Division
Kaistraße 18
40221 Düsseldorf, Germany
Tel.: 0049-(0)211-994597-0, Fax: 0049-(0)211-994597-40

teNeues Publishing UK Ltd.
P.O. Box 402
West Byfleet
KT14 7ZF, Great Britain
Tel.: 0044-1932-403509, Fax: 0044-1932-403514

teNeues France S.A.R.L.
4, rue de Valence
75005 Paris, France
Tel.: 0033-1-55 76 62 05, Fax: 0033-1-55 76 64 19

www.teneues.com

ISBN: 3-8327-9037-3

© 2005 teNeues Verlag GmbH + Co. KG, Kempen

Printed in Spain

Bibliographic information published by
Die Deutsche Bibliothek. Die Deutsche Bibliothek lists
this publication in the Deutsche Nationalbibliografie;
detailed bibliographic data is available in the Internet
at http://dnb.ddb.de.

Contents

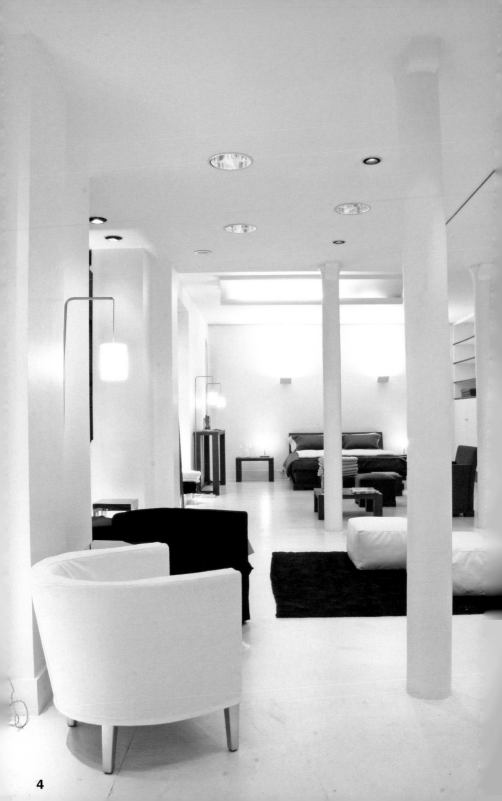

Introduction

La construction de la Place des Vosges entre 1605 et 1612 ou celle de la Place Vendôme de 1699 à 1720 offrent deux exemples fondateurs de la construction d'un ensemble important de demeures sous un même toit : une tradition qui saurait évoluer pour se convertir par la suite en l'un des particularismes de Paris. La profonde réforme urbanistique, menée à bien par le baron G. Haussmann (1809-1891) se réclame également de cette caractéristique. Elle lègue à la capitale de la France non seulement ses grands boulevards et une nouvelle structure des rues et des avenues mais elle parachève également une norme urbanistique fruit de plus de deux siècles d'évolution. Cette tradition dans le tracé de la cité lui confère une personnalité dont peu d'autres villes de par le monde peuvent s'enorgueillir. Une tradition qui cherche à se perpétuer de nos jours.

La partie commerciale se trouve au cœur de la ville. Elle s'étend des vastes boulevards haussmanniens jusqu'au étroites ruelles du Marais, quartier au combien médiéval. Dans les deux cas, persiste une loi obligeant à respecter les façades des monuments historiques. Pour cette raison, nombre de boutiques ne sauraient profiter de grandes vitrines donnant sur la rue. Cette normative et la tradition commerçante de la cité ont généré un intérêt démesuré envers les devantures, où le jeu de cache-cache se déploie toujours avec une souveraine subtilité. La réforme des intérieurs, en raison de la sensibilité tant des architectes que des propriétaires, a mené dans de nombreux cas à une valorisation des éléments préexistants, parfois des détails infimes, afin de proposer un contraste avec le nouvel intérieur. S'inscrivant dans cette ligne, l'une des tendances ultimes du moment en matière de design d'intérieurs postule la décoration avec du mobilier baroque, chaises et tables pour l'essentiel, afin de souligner des espaces minimalistes par des effets scénographiques. Paris, capitale française de la mode, continue de faire montre depuis des siècles de son attention à l'heure de présenter une riche palette d'objets allant du détail le plus anodin à la vitrine la plus monumentale, des lieux mêlant tradition et modernité.

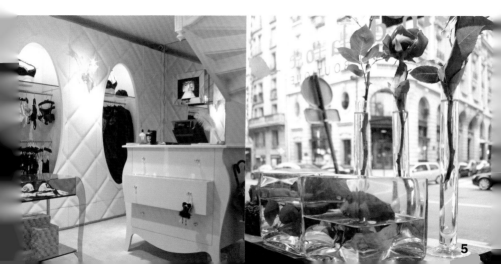

Introduction

The construction of the Place des Vosges, between 1605 and 1612, or the Place Vendôme, during 1699 and 1720, are two early examples of the placement of an important group of residences behind a single unifying façade, a tradition that will evolve and become one of the particularities of Paris. The profound urbanistic reform carried out by Baron G. Haussmann (1809–1891) also included this architectural characteristic. That reform bequeathed to the French capital not only grand boulevards and a new grid of streets and avenues, but also completed the shape of an urbanistic code which was the fruit of more than two hundred years of development. This tradition in the city's layout left it with a character which few other cities of the world possess, and one whose conservation is currently sought.

The commercial area is located in the heart of the city. It extends from the wide boulevards laid out by Baron Haussmann to the narrow streets of Le Marais, a neighborhood of medieval origin. In both cases, a law exists that requires respect for the façade of historical buildings; thus, many of the shops are not fitted with large show windows that look onto the street. This ordinance, along with the city's shop-keeping tradition, has generated an inordinate amount of interest in window dressing, where the game of revealing and concealing is always carried out with great subtlety. The reform of the interiors, given the sensitivity both of architects and of proprietors, has led to a situation where in many cases the preexisting elements are valued, even if they are minimal details, so as to contrast with the new interior. Following this line, one of the latest current trends in the design of interiors is that of decorating with baroque furniture—above all chairs and tables—in a way that uses scenographic effects to make the furniture stand out in minimalist spaces.

Paris, the French fashion capital, continues after many centuries to demonstrate its care when it comes to presenting an extensive variety of objects, ranging from the tiniest detail to the largest show window, where tradition and modernity are richly mixed.

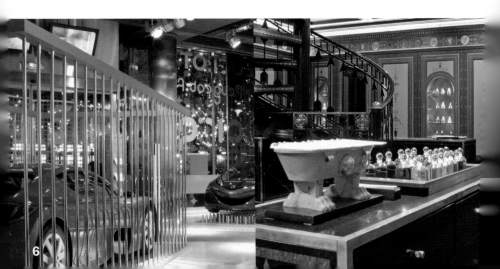

Einleitung

Die Errichtung des Place des Vosges zwischen 1605 und 1612 und die des Place Vendôme in den Jahren 1699 bis 1720 sind zwei frühe Beispiele für den Bau eines großen Gebäudeensembles mit einzelnen Wohnungen hinter einer einzigen Fassade, eine Tradition, die sich weiterentwickeln und zu einer der Besonderheiten von Paris werden sollte. Die tief greifenden urbanistischen Eingriffe, die Baron G. Haussmann (1809–1891) durchführte, griffen diese Besonderheit ebenfalls wieder auf. Er hinterließ der Hauptstadt Frankreichs nicht nur ihre großen Boulevards und eine neue Straßenstruktur, sondern er legte auch die Grundlagen einer Norm für den Städtebau, die Ergebnis einer zweihundertjährigen Entwicklung war. Diese Tradition in der Stadtordnung hat Paris einen Charakter verliehen, den wenige andere Städte der Welt besitzen, und heutzutage versucht man, diesen besonderen Charakter zu bewahren.

Die Geschäftsviertel der Stadt befinden sich im Zentrum. Sie erstrecken sich von den weiten Boulevards im Stil Haussmanns bis zu den engen Straßen des Marais, dem mittelalterlichen Viertel. Für diese Viertel existiert ein Gesetz, das dazu verpflichtet, die Fassaden der historischen Gebäude zu erhalten. Deshalb besitzen viele der Geschäfte keine großen Schaufenster zur Straße. Diese Verordnung und die Handelstradition der Stadt haben ein besonders großes Interesse an der Schaufenstergestaltung bewirkt, denn hier muss das Spiel des Zeigens und Versteckens mit sehr viel Raffinesse gespielt werden. Bei den Renovierungen der Innenräume, bei denen das Feingefühl der Architekten und der Eigentümer eine große Rolle spielt, wurden in vielen Fällen die bereits existierenden Elemente weitestgehend berücksichtigt, auch wenn es sich um winzige Details handelte, sodass sie zu den neu gestalteten Räumen einen Kontrast bilden. In dieser Linie liegen auch die letzten Trends der Innenarchitektur; man dekoriert mit barocken Möbeln, vor allem mit Stühlen und Tischen, um so minimalistische Einzelheiten mit bühnenhafter Wirkung zu inszenieren.

Paris, die französische Hauptstadt der Mode, zeigt auch nach mehreren Jahrhunderten noch immer seine Sorgfalt bei der Präsentation einer Vielfalt an Objekten, angefangen beim kleinsten Detail bis hin zum größten Schaufenster, in dem sich Tradition und Modernität mischen.

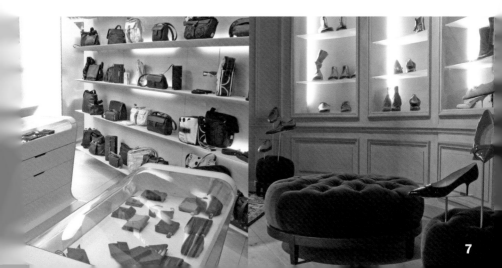

Introducción

La construcción de la Place des Vosges entre 1605 y 1612 o la Place Vendôme durante los años 1699 y 1720 son dos ejemplos tempranos de la construcción de un conjunto importante de viviendas bajo una fachada unitaria; una tradición que evolucionará y se convertirá en una de las particularidades de París. La profunda reforma urbanística que llevó a cabo el barón G. Haussmann (1809-1891) también recogió esta característica. Legó a la capital francesa no sólo los grandes bulevares y una nueva estructura de calles y avenidas, sino que también acabó de perfilar una normativa urbanística fruto de más de doscientos años de evolución. Esta tradición en el trazado de la ciudad la ha dotado de un carácter que pocas otras ciudades del mundo poseen, y hoy en día se busca su conservación.

El área comercial se sitúa en el corazón de la ciudad. Se extiende desde los anchos bulevares haussmannianos hasta las estrechas calles de Le Marais, barrio de origen medieval. Existe en ambos casos una ley que obliga a respetar la fachada de los edificios históricos, por lo que muchas de las tiendas carecen de grandes lunas que dan a la calle. Esta ordenanza y la tradición comerciante de la ciudad han generado un desmesurado interés por el escaparatismo, donde el juego de mostrar y ocultar se lleva a cabo siempre con gran sutileza. La reforma de los interiores, dada la sensibilidad tanto de arquitectos como de propietarios, ha llevado a que en muchos casos se valore elementos preexistentes, aunque sean detalles mínimos, para que contrasten con el nuevo interior. Siguiendo esta línea, actualmente una de las últimas tendencias en el diseño de interiores es la de decorar con mobiliario barroco, sobre todo sillas y mesas, para que destaquen en espacios minimalistas con efectos escenográficos.

París, capital francesa de la moda, sigue demostrando después de varios siglos su cuidado a la hora de presentar una extensa variedad de objetos, que van desde el detalle más pequeño hasta el escaparate más grande, en los que conviven tradición y modernidad.

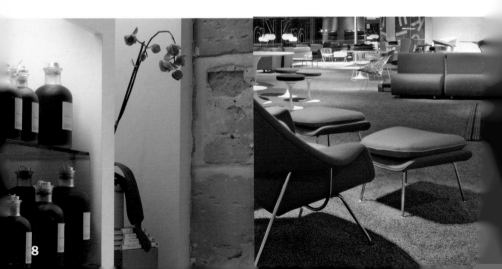

Introduzione

La costruzione della Place des Vosges tra il 1605 e il 1612 o la Place Vendôme tra il 1699 e il 1720 sono due esempi precoci della realizzazione di un importante complesso abitativo sotto un'unica facciata; una tradizione che si evolverà, diventerà una delle peculiarità di Parigi, e sarà presente anche nella profonda riforma urbanistica attuata dal barone G. Haussmann (1809-1891). Quest'ultima non solo lasciò alla capitale francese grandi boulevar e un nuovo reticolo di strade e viali, ma finì per dare gli ultimi tocchi a una normativa urbanistica frutto di oltre duecento anni. Le notevoli peculiarità del suo tracciato urbano hanno dotato la città di un carattere che poche altre città al mondo posseggono, e che attualmente si sta cercando di conservare.

La zona commerciale si trova nel cuore della città e va dagli ampi boulevar haussmanniani fino alle stradine strette di Le Marais, il quartiere di origine medievale. In entrambi i casi esiste una legge che obbliga a rispettare la facciata degli edifici storici, per cui molti dei negozi non dispongono di grandi vetrine che danno sulla strada. Per contro, questa ordinanza e la tradizione commerciale della città hanno generato uno smisurato interesse per l'allestimento di vetrine, dove il gioco tra il mettere in mostra e il nascondere si esegue sempre con grande finezza. In molti casi, per la sensibilità sia degli architetti che dei proprietari, la ristrutturazione degli interni ha messo in rilievo elementi già esistenti, a volte anche minimi dettagli, per creare una sorta di contrasto con il nuovo arredamento. Sulla scia di questa linea, attualmente una delle ultime tendenze nell'arredamento di interni è quella di decorare gli ambienti con mobili di stile barocco, soprattutto sedie e tavoli, in netto contrasto con gli spazi minimalisti dagli effetti scenografici.

Parigi, capitale francese della moda, dimostra ancora dopo tanti secoli la sua attenzione nel presentare una vasta varietà di oggetti, che vanno dal più piccolo dettaglio fino alla vetrina più grande, nei quali convivono la tradizione e la modernità.

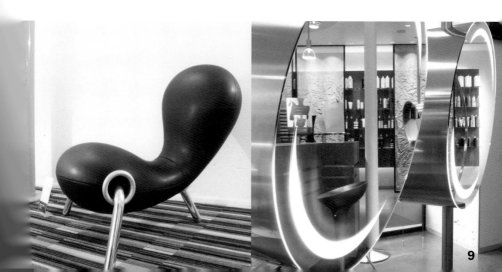

Antoine et Lili

Design: Antoine et Lili with Jean François Laguenière

95, Quai de Valmy | 75010 Paris
Phone: +33 1 42 05 62 23
www.altribu.com
Subway: Gare de l'Est, République
Opening hours: Mon 11 am to 7:30 pm, Tue–Fri 11 am to 8 pm, Sat 10:30 am
to 8 pm, Sun 11 am to 7 pm
Products: Clothing, accessories, small decorative objects
Special features: Pop clothes and objects in a funny seating

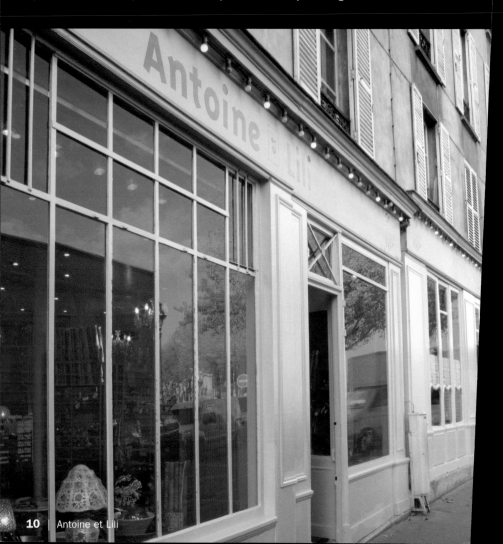

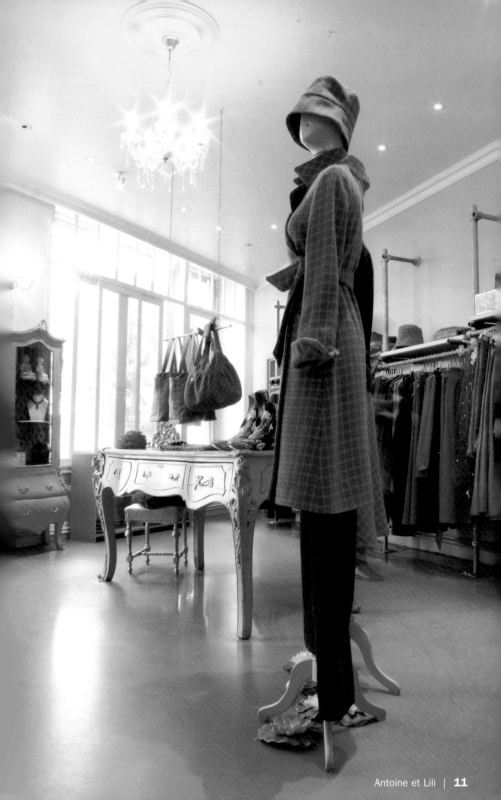

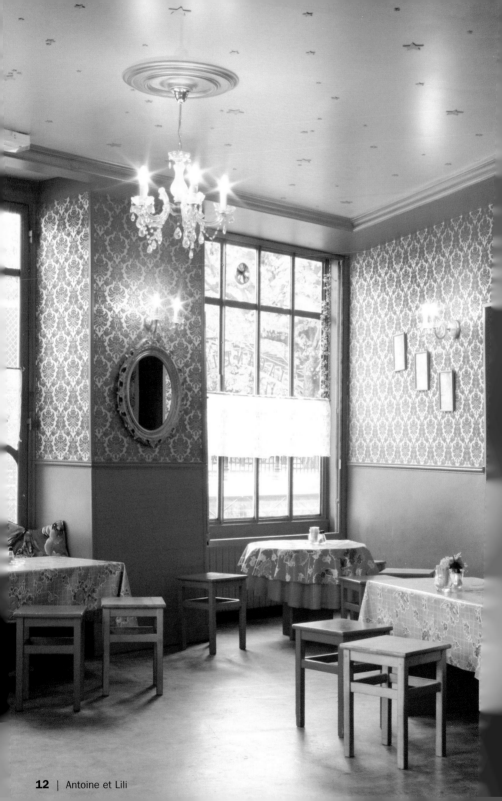

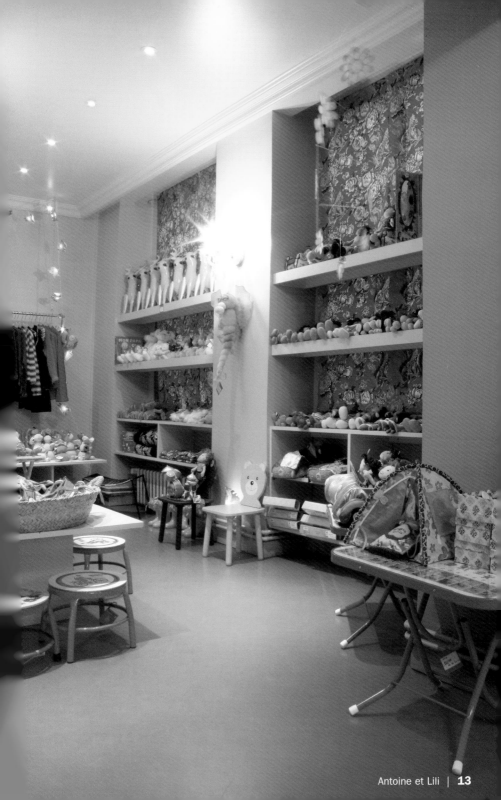

A-Poc Space

Design: Ronan and Erwan Bouroullec

47, Rue des Francs-Bourgeois | 75004 Paris
Phone: +33 1 44 54 07 05
Subway: Saint-Paul
Opening hours: Every day from 11 am to 7 pm
Products: Clothes and accessories
Special features: Atelier, laboratory, both exhibition and sales place, stylized and organic atmosphere

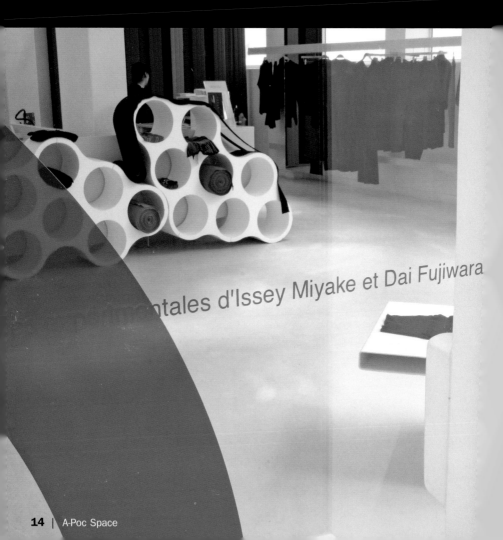

ntales d'Issey Miyake et Dai Fujiwara

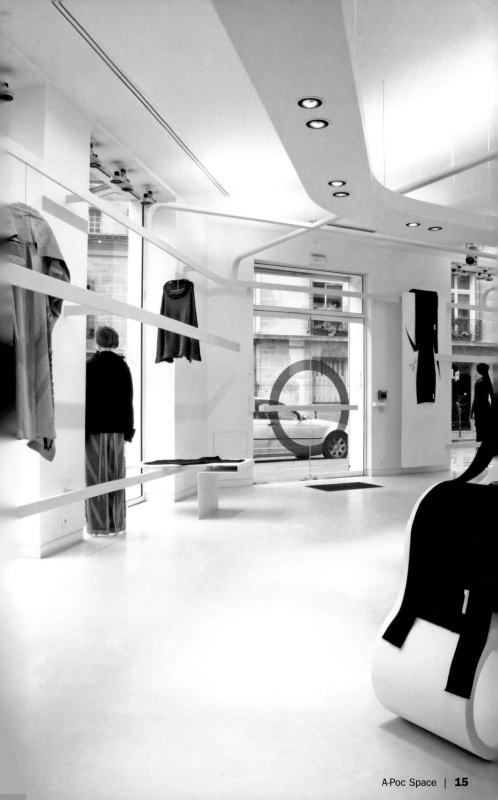

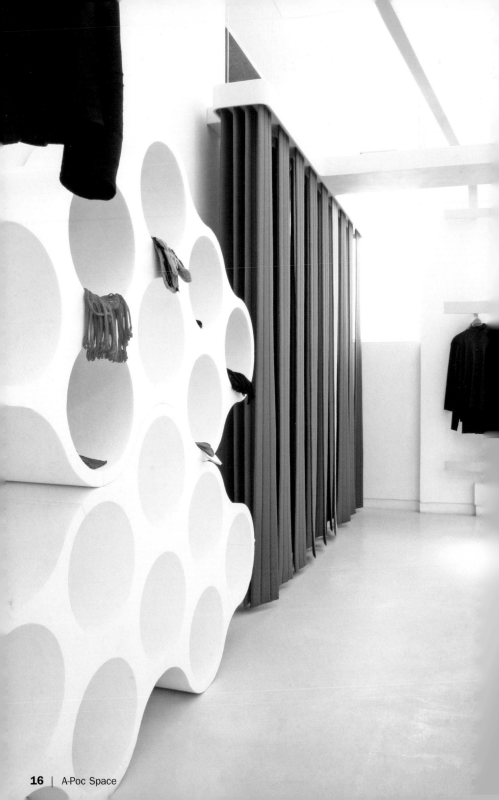

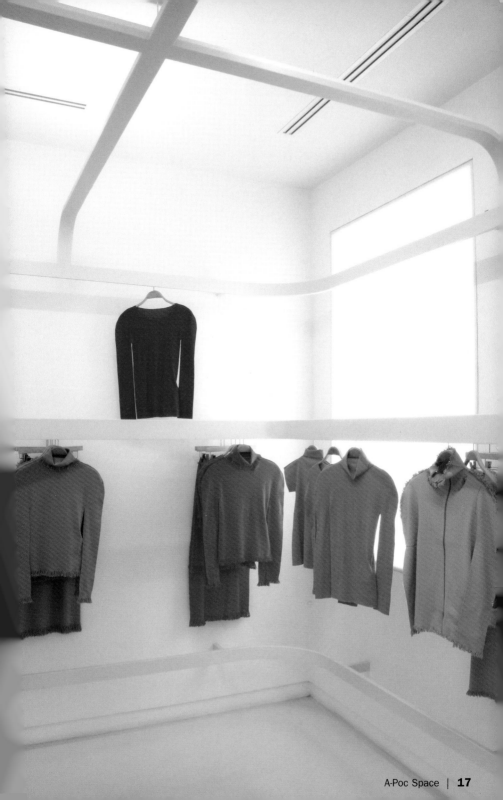

Artelano

Design: Didier Gomez

54, Rue de Bourgogne | 75007 Paris
Phone: +33 1 44 18 00 00
www.artelano.com
Subway: Varenne
Opening hours: Mon–Sat 10:30 am to 1 pm and 1:30 pm to 7 pm
Products: Contemporary furniture by international designers
Special features: The image of the company was best on pure lines and functionalism

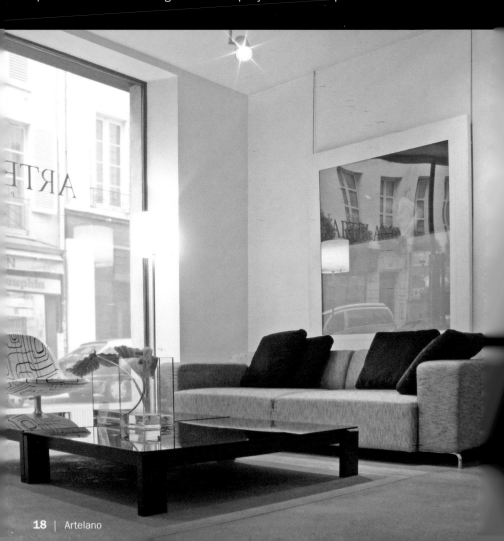

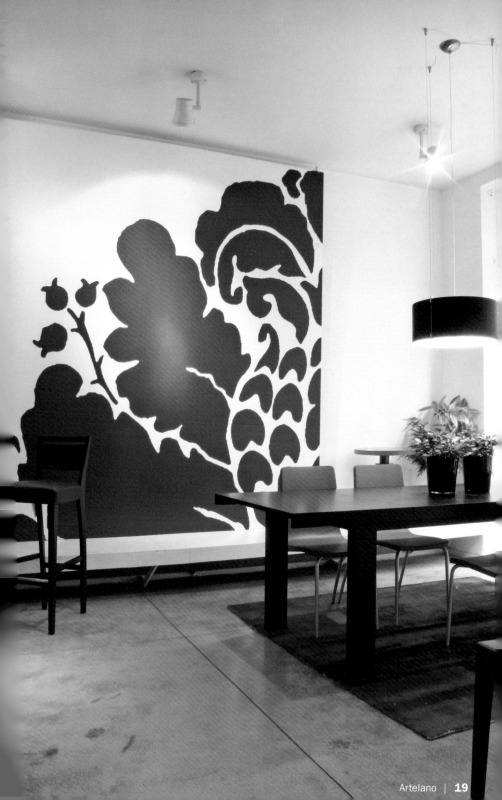

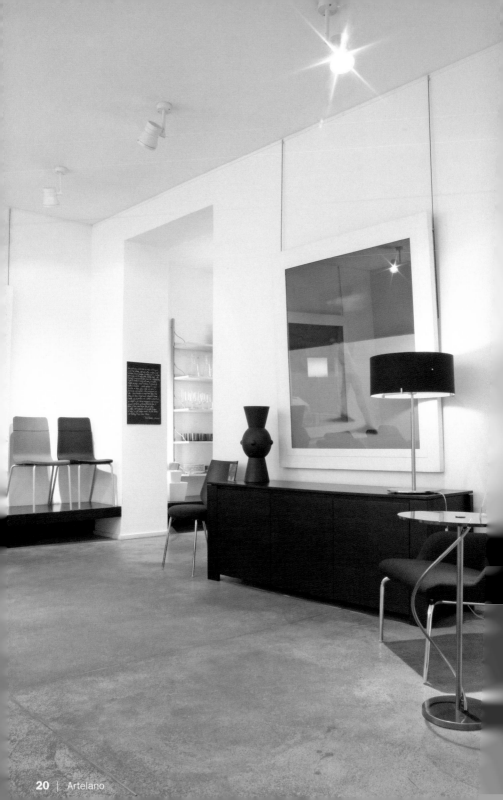

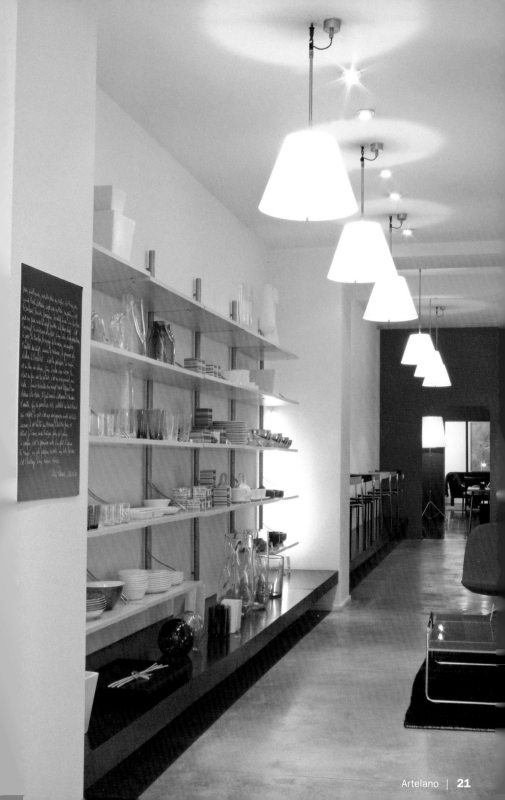

Au nom de la rose

Design: Jérôme Bouët and Cécile Halley des Fontaines

46, Rue du Bac | 75007 Paris
Phone: +33 1 42 22 08 09
www.aunomdelarose.fr
Subway: Rue du Bac
Opening hours: Mon–Sat 9 am to 9 pm, Sun 9 am to 2 pm
Products: Roses of various colors and perfumes, sprays, candles and food
Special features: More than 150 varieties of roses, from garden roses to
ancient ones

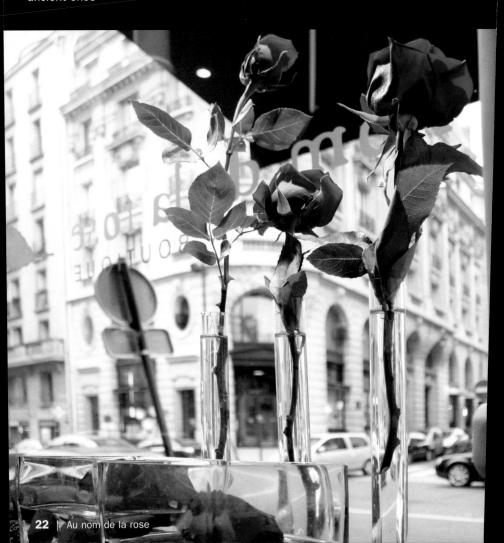

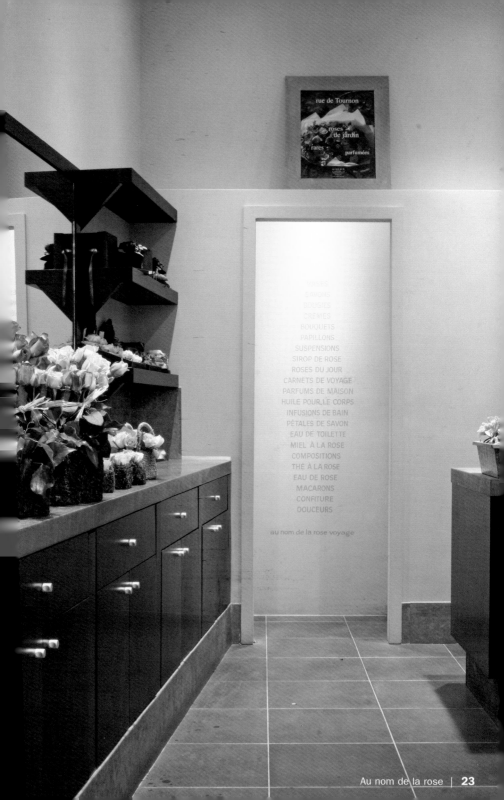

Le roseau est le cœur du Monde
Comme le cœur est le cœur
du corps.

Tennessee Williams

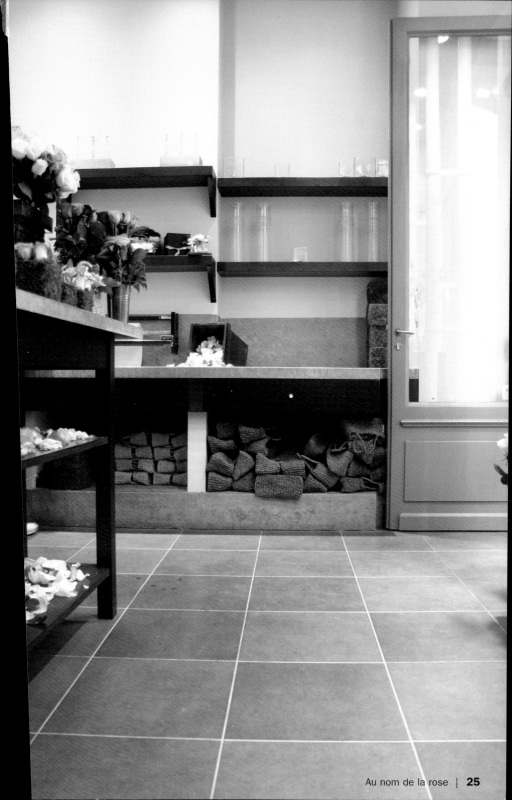

Biche de Bere

Design: Nelly Biche de Bere

61, Rue de la Verrerie | 75004 Paris
Phone: +33 1 42 78 22 03
www.bichedebere.fr
Subway: Hôtel-de-Ville
Opening hours: Mon–Sat 11 am to 8 pm
Products: Prêt-à-porter collections and jewelry
Special features: Internationally renowned brand, original and sublime collections

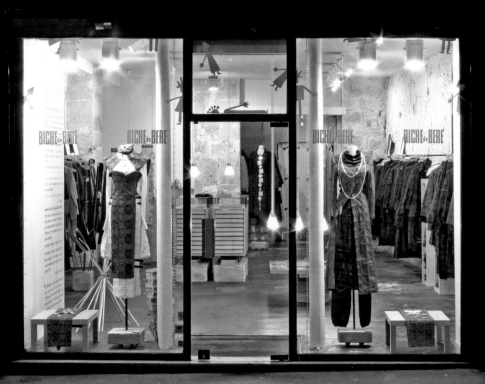

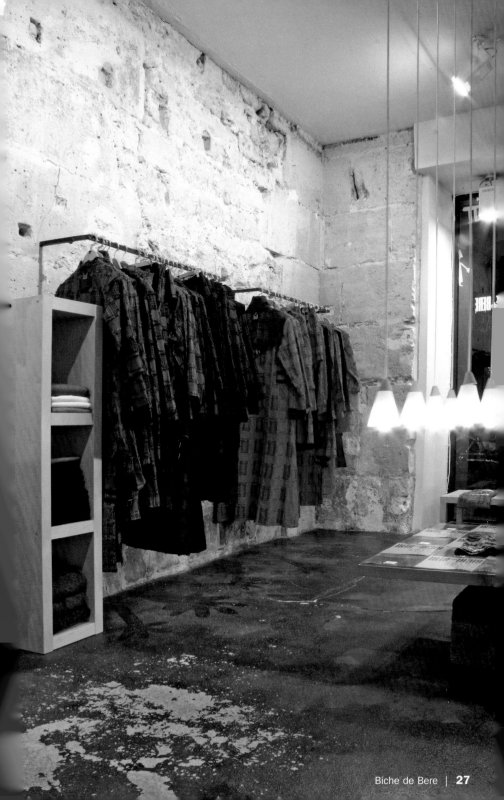

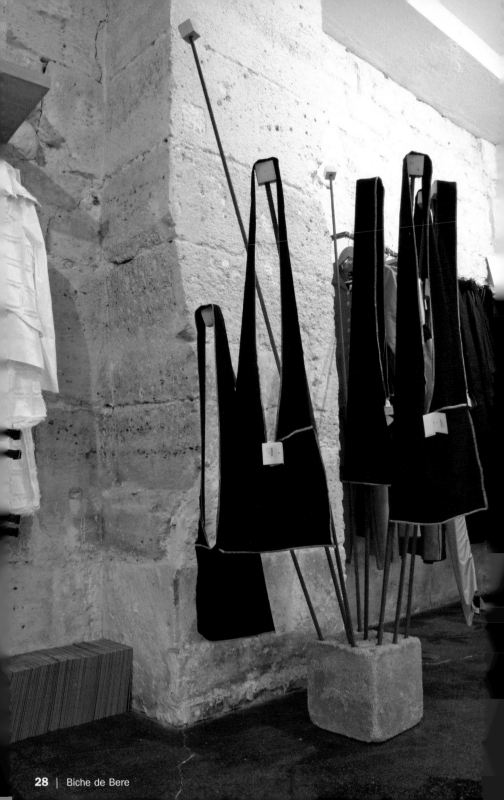

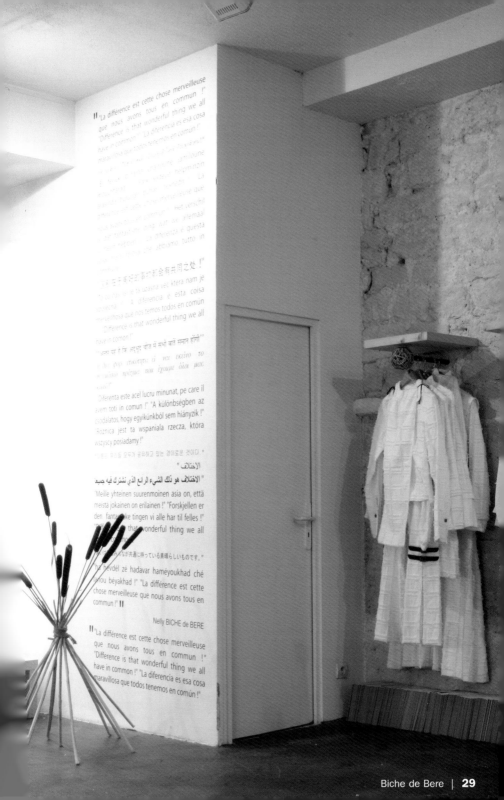

Bottega Veneta

Design: Tomas Maier and William Sofield

14–16, Rue du Faubourg-Saint-Honoré | 75008 Paris
Phone: +33 1 42 65 59 70
www.bottegaveneta.com
Subway: Madeleine
Opening hours: Mon–Sat 10:30 am to 7 pm
Products: Luxury accessories
Special features: The shop respects the existing architecture of the building while creating something contemporary, timeless and beautiful

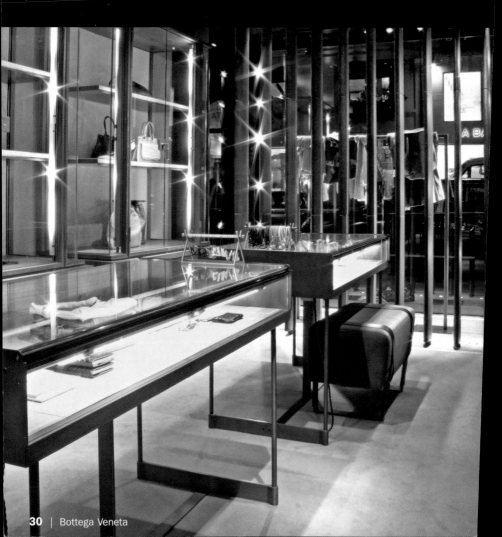

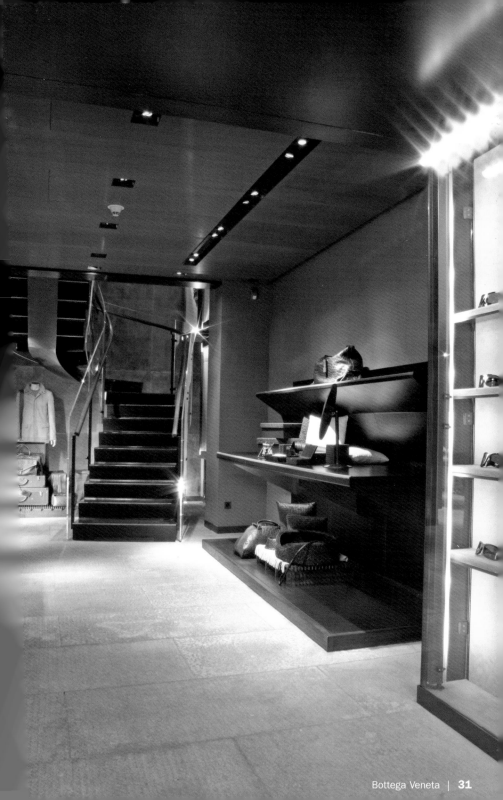

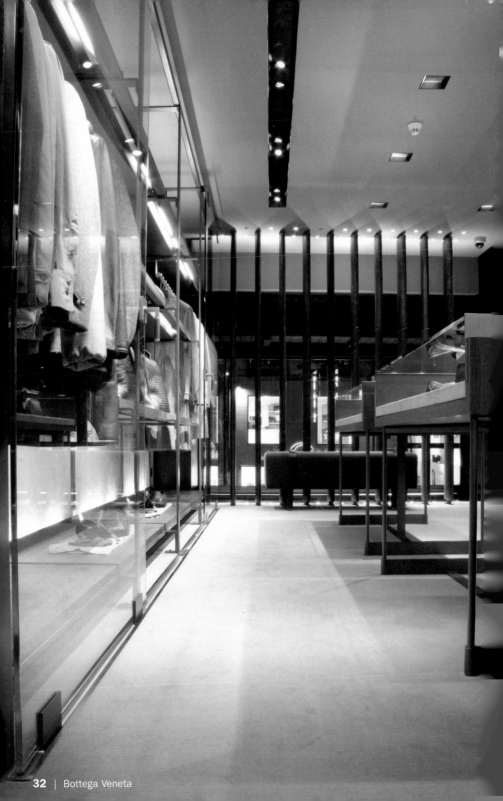

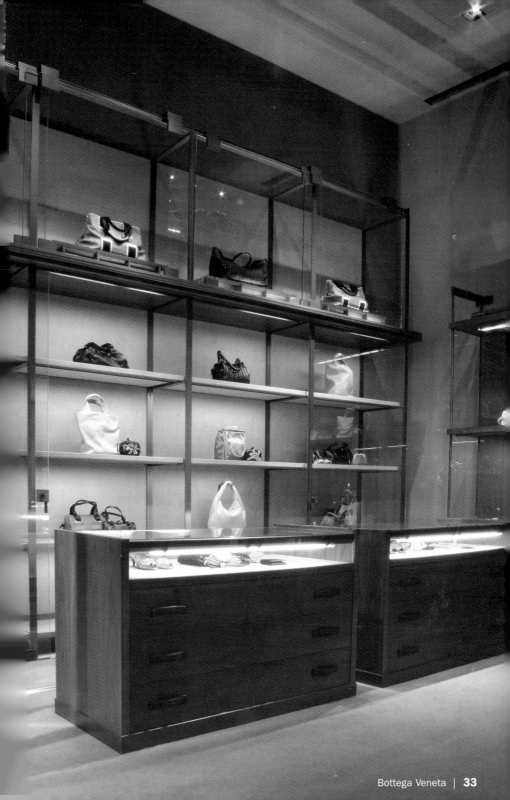

Boutique John Galliano

Design: Jean-Michel Wilmotte with John Galliano

384–386, Rue Saint-Honoré | 75001 Paris
Phone: +33 1 55 35 40 40
www.johngalliano.com
Subway: Concorde, Madeleine
Opening hours: Mon–Sat 11 am to 7 pm
Products: High range prêt-à-porter
Special features: One space for living the "high-tech romance" sensations

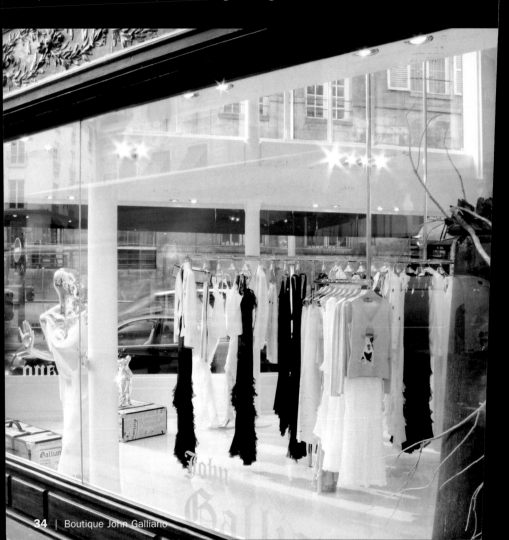

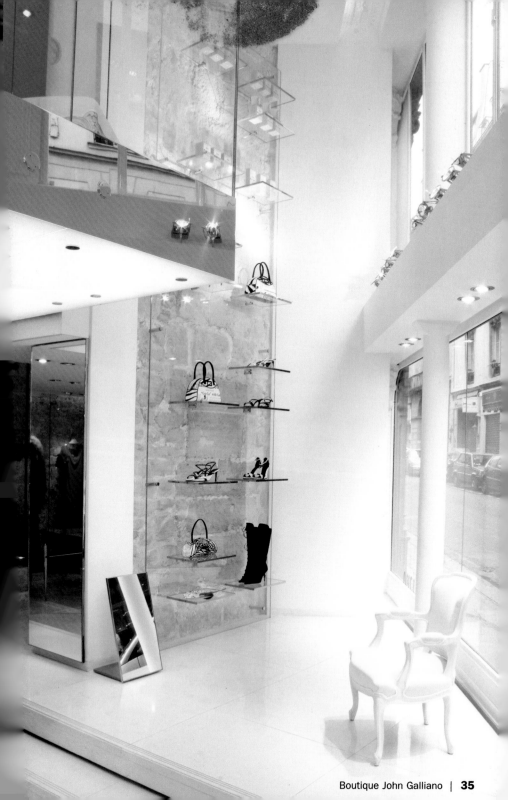

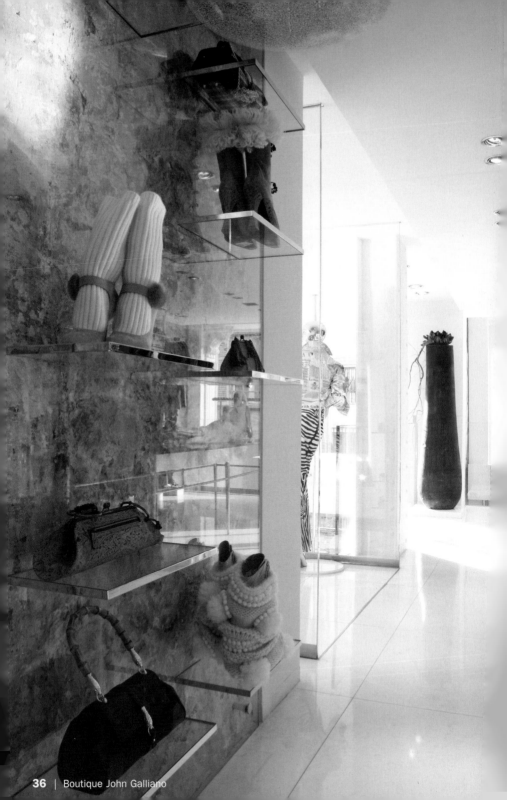

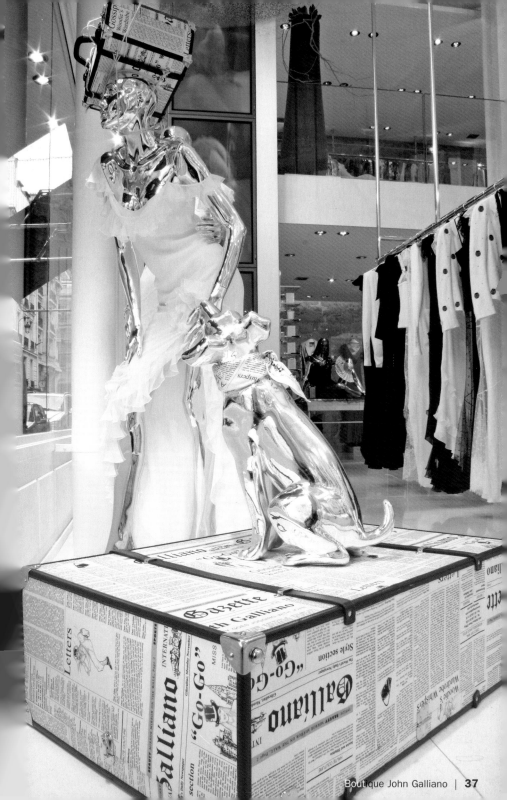

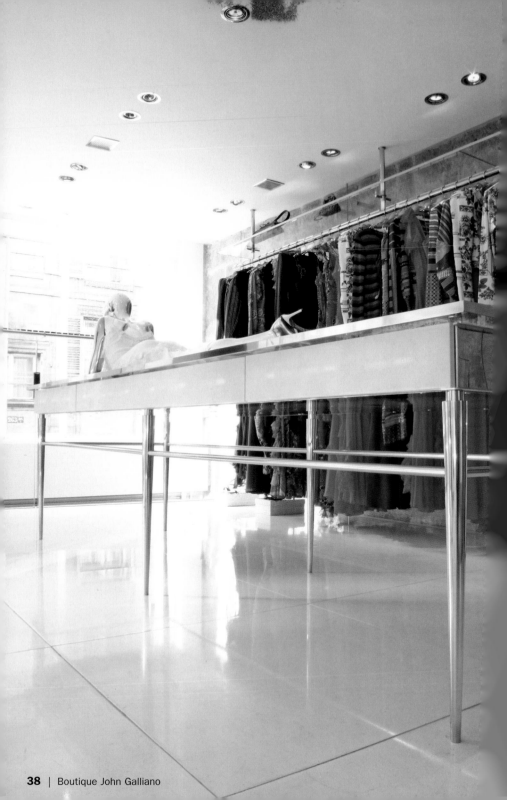

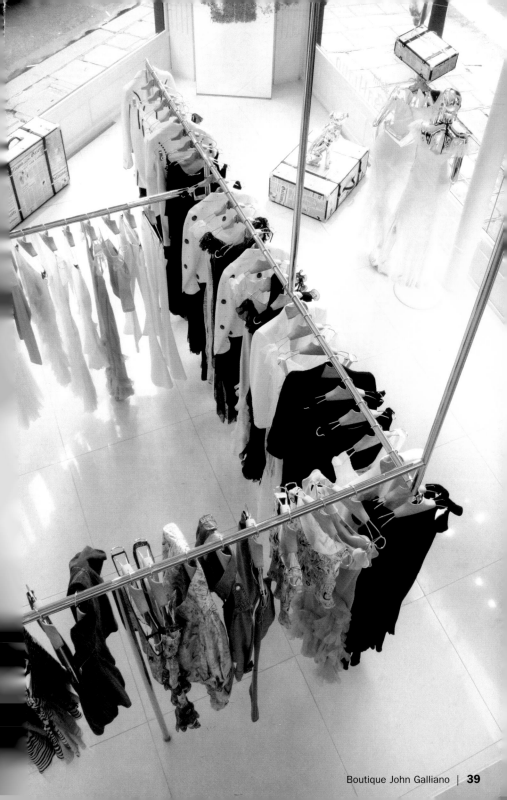

Calligrane

Design: Calligrane

4–6, Rue du Pont-Louis-Philippe | 75004 Paris
Phone: +33 1 48 04 31 89
Subway: Pont Marie, Saint-Paul
Opening hours: Mon–Sat 11 am to 7 pm
Products: Haute couture paper
Special features: Homework notebooks and works in paper from international designers

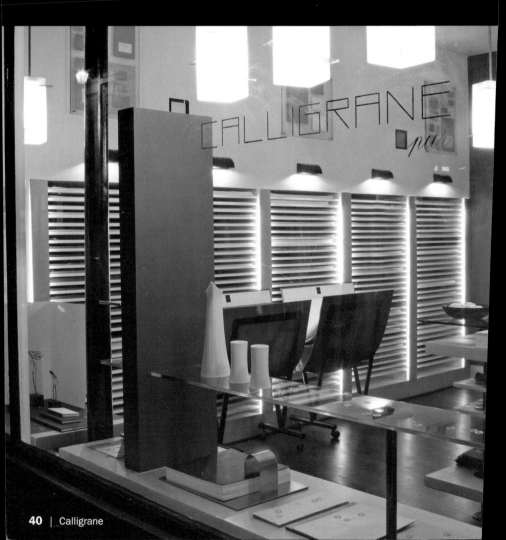

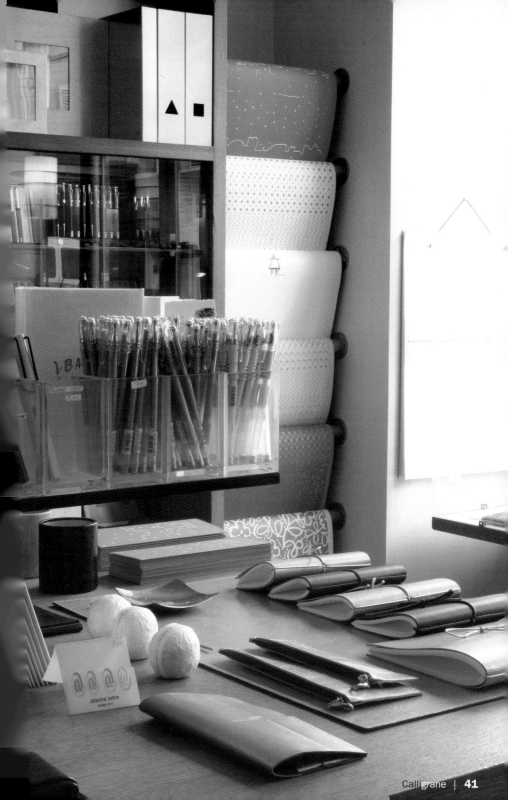

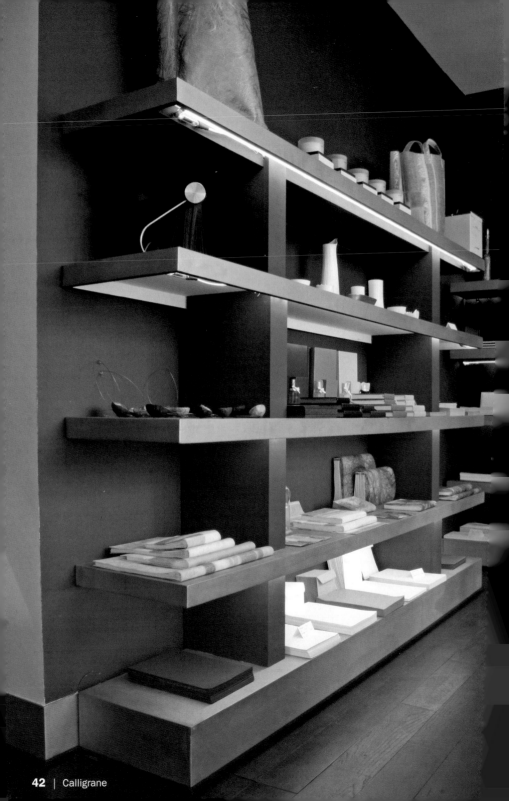

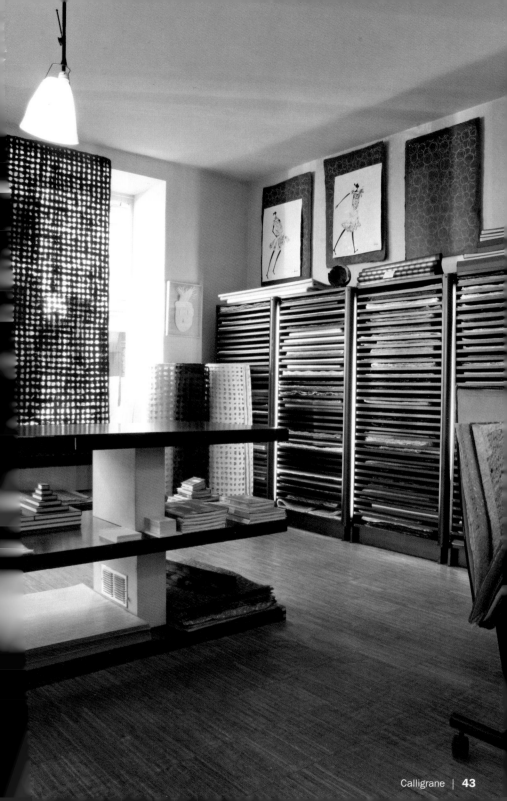

Camper

Design: Shiro Miura

14–16, Rue du Faubourg-Saint-Honoré | 75008 Paris
Phone: +33 1 42 68 13 65
www.camper.com
Subway: Madeleine
Opening hours: Mon–Sat 11 am to 7 pm
Products: Casual shoes
Special features: A mixture of Japanese and Mediterranean culture, creating
a combination of bright and rough elements

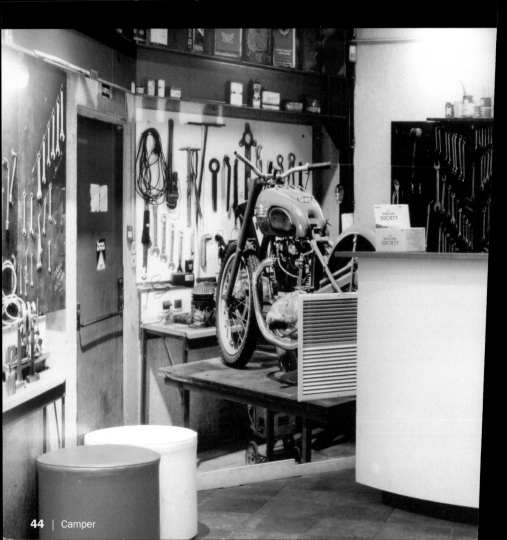

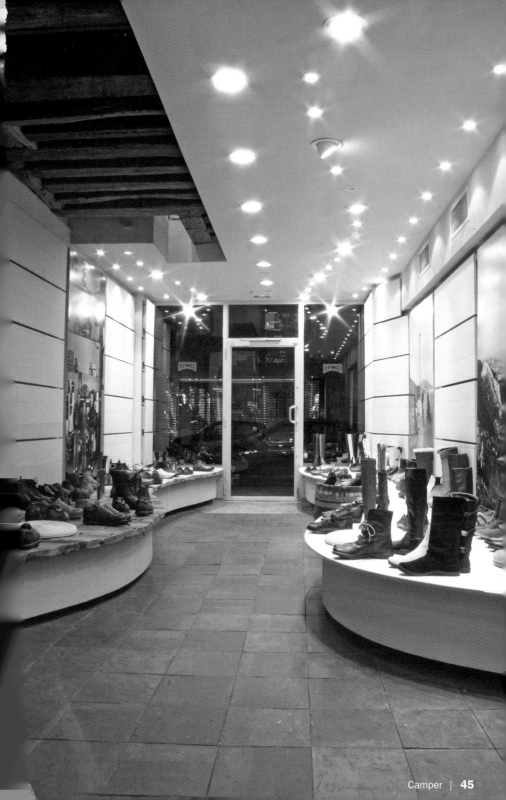

Chantal Thomass

Design: Christian Ghion

211, Rue Saint-Honoré | 75001 Paris
Phone: +33 1 42 60 40 56
Subway: Tuileries, Pyramides
Opening hours: Mon–Sat 11 am to 7 pm
Products: Lingerie and night lingerie
Special features: A contemporary boudoir with all Chantal Thomass' designs

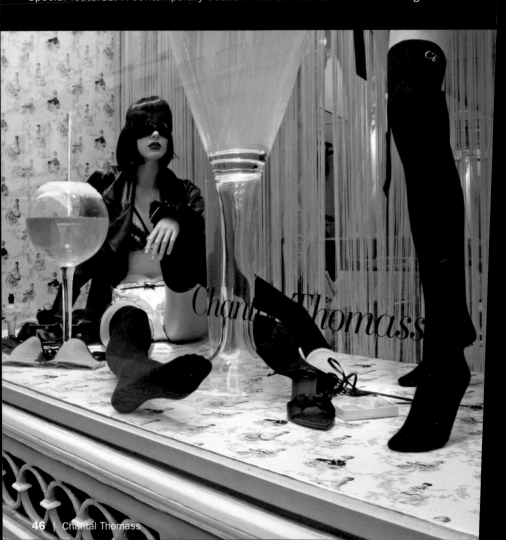

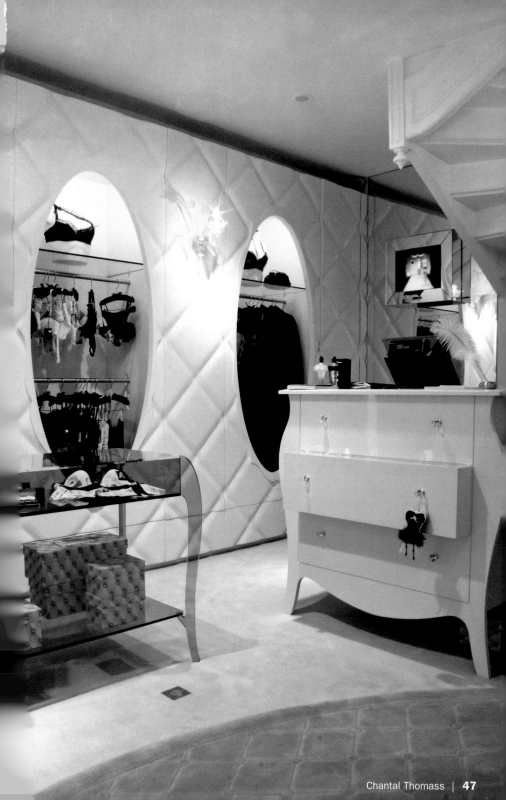

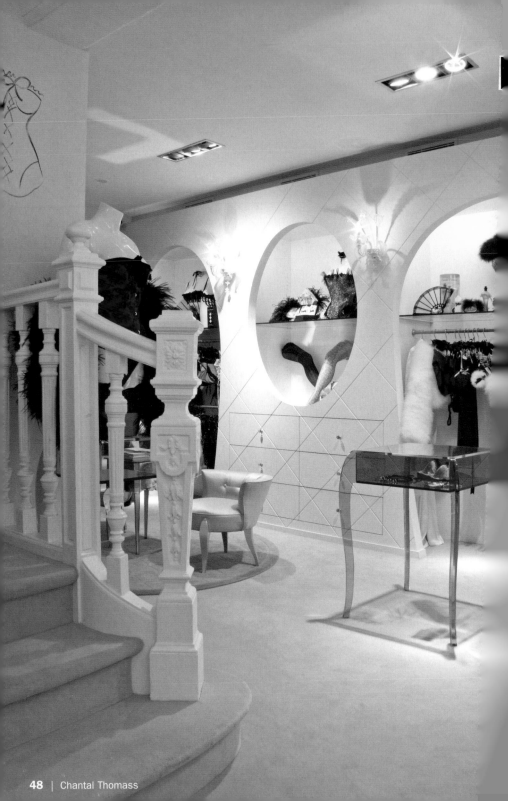

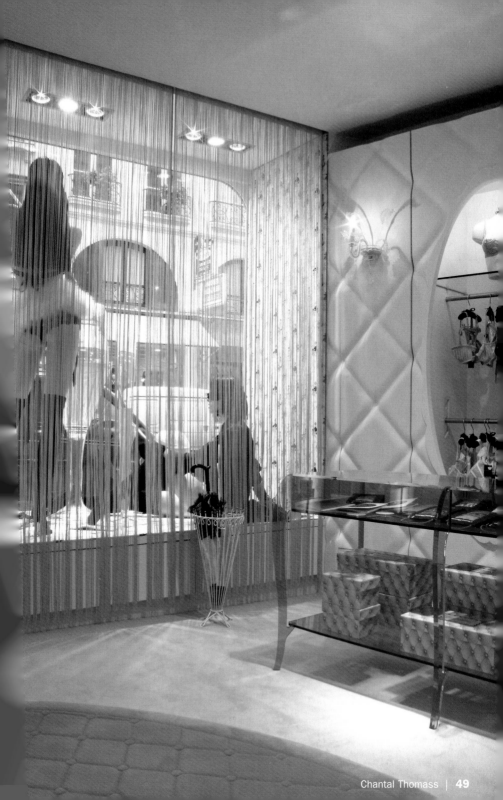

Colette

Design: Arnaud Montigny

213, Rue Saint-Honoré | 75001 Pairs
Phone: +33 1 55 35 33 90
www.colette.fr
Subway: Tuileries, Pyramides
Opening hours: Mon–Sat 11 am to 7 pm
Products: Style, Design, Art, Food and Beauty
Special features: In a clear and bright space of 700 m², Colette intends to reinvent the idea of shopping

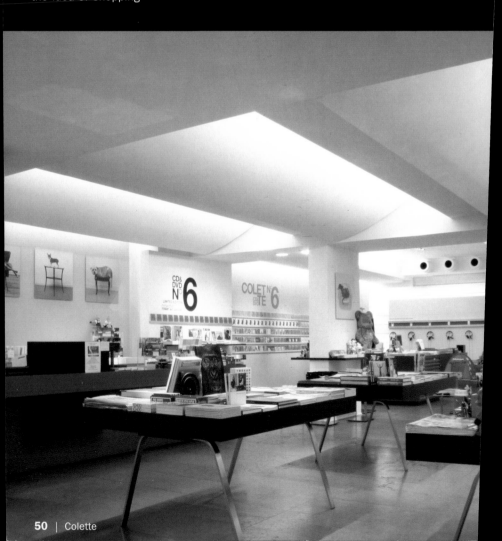

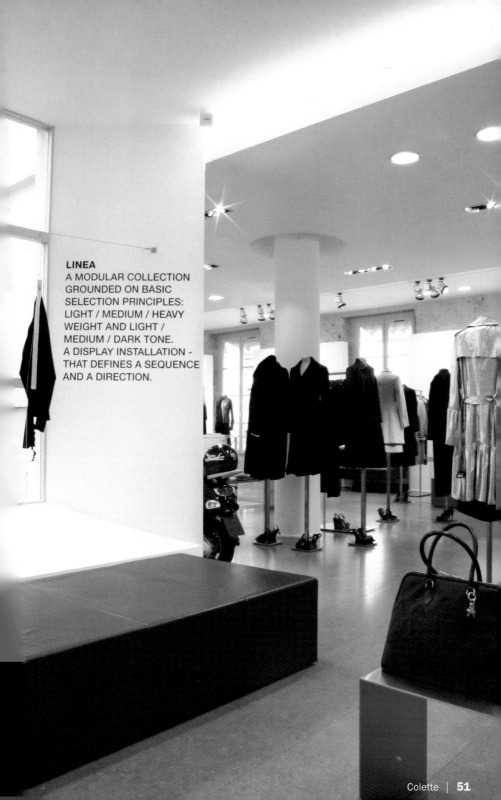

LINEA
A MODULAR COLLECTION
GROUNDED ON BASIC
SELECTION PRINCIPLES:
LIGHT / MEDIUM / HEAVY
WEIGHT AND LIGHT /
MEDIUM / DARK TONE.
A DISPLAY INSTALLATION -
THAT DEFINES A SEQUENCE
AND A DIRECTION.

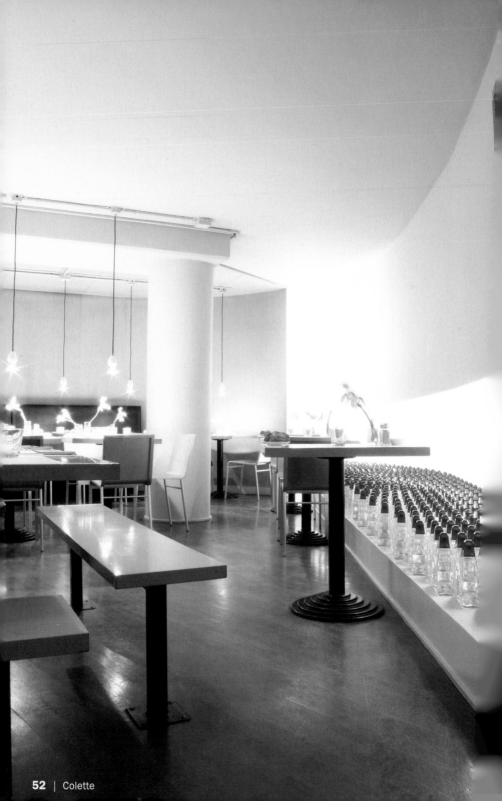

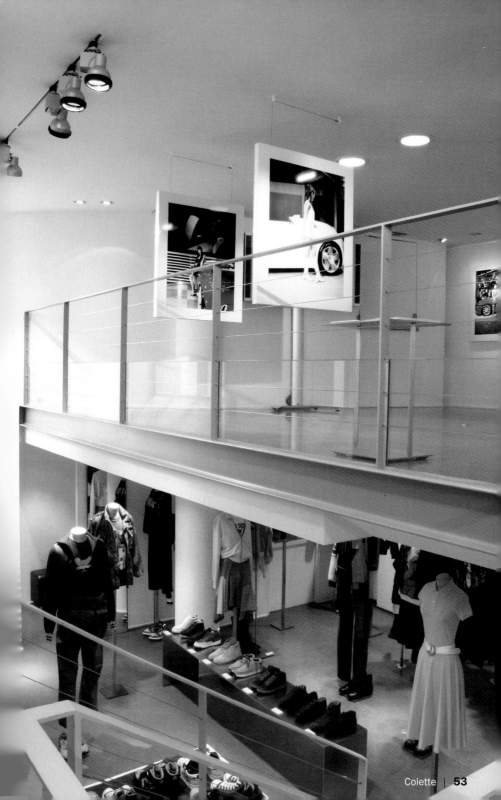

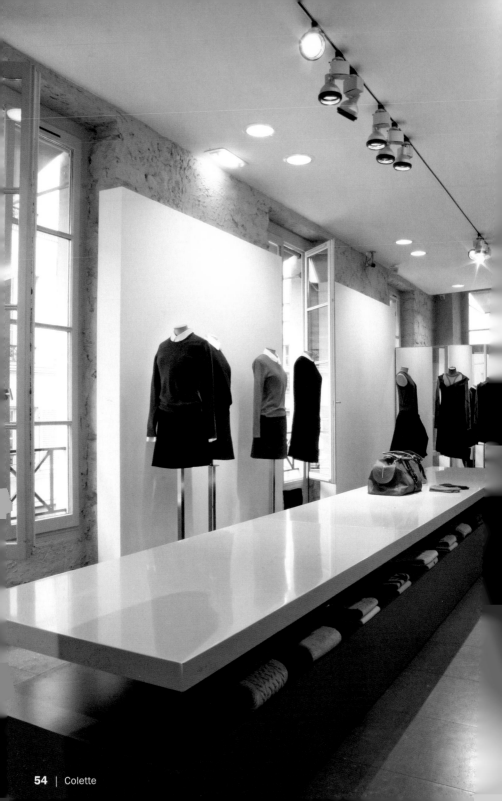

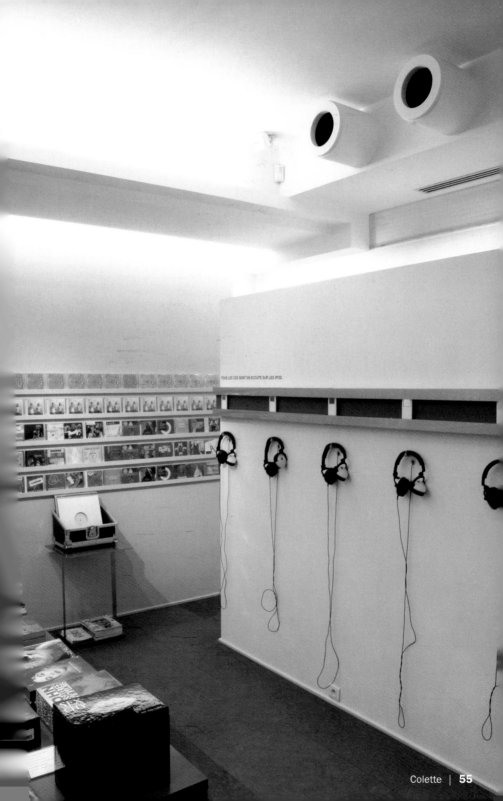

TOUS LES CDS SONT EN ECOUTE SUR LES IPOD.

Dolce & Gabbana

Design: David Chipperfield Architects

22, Avenue Montaigne | 75008 Paris
Phone: +33 1 42 25 68 78
www.dolcegabbana.it
Subway: Franklin-D.-Roosevelt
Opening hours: Mon–Sat 10 am to 7 pm
Products: Clothes and accessories
Special features: The glamour and versatility of Dolce & Gabbana in a space

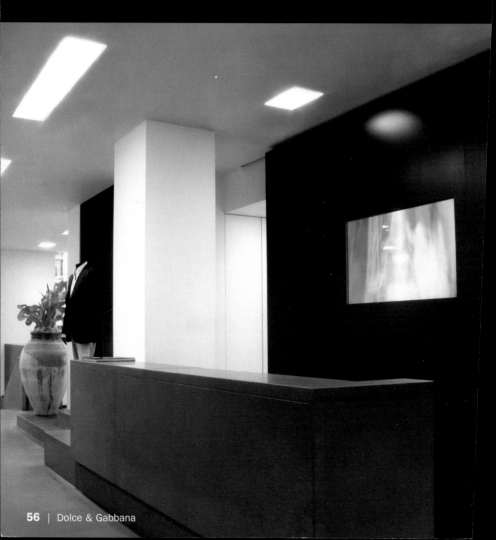

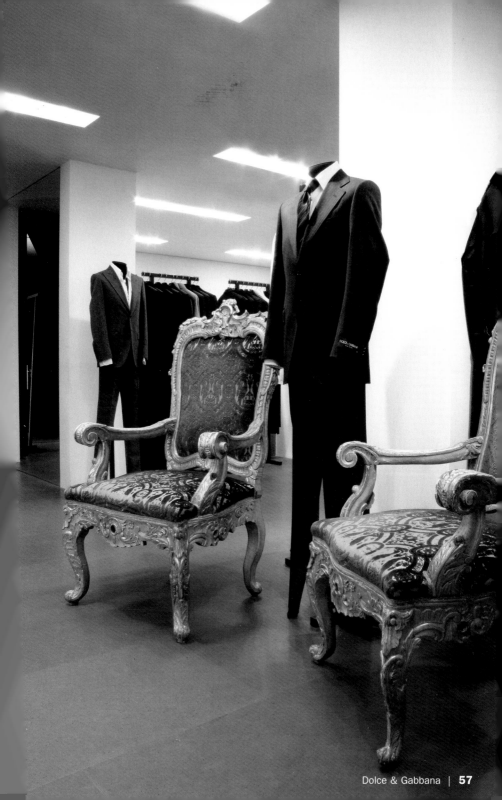

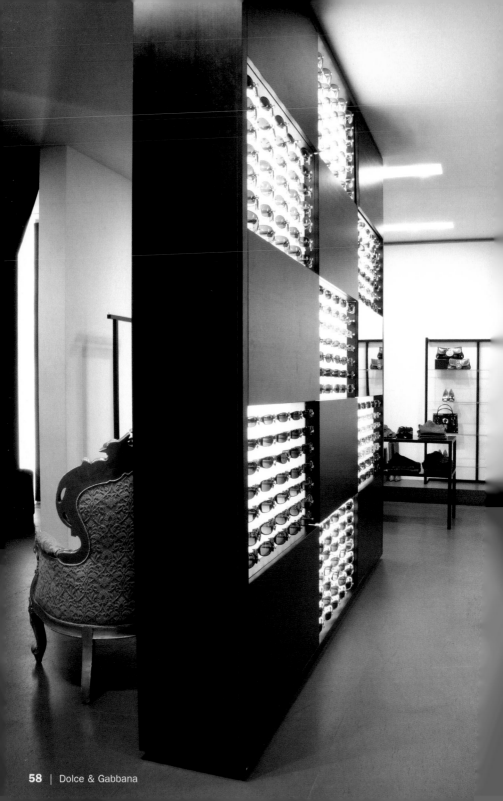

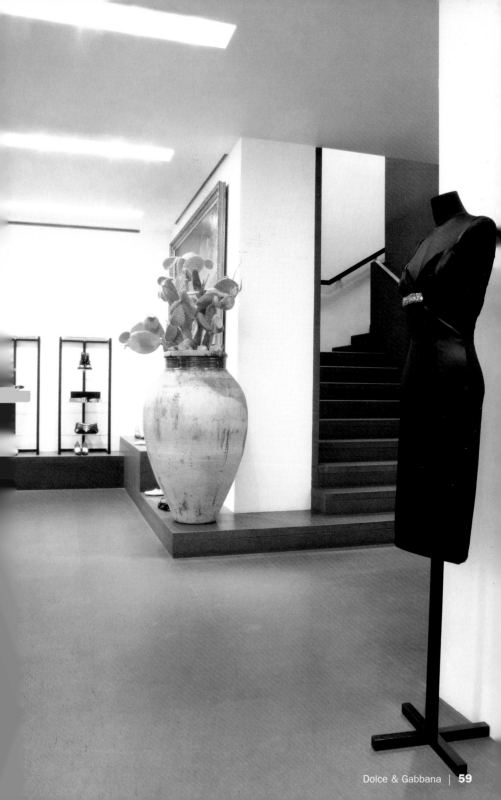

www.faceaface-paris.com
Subway: Tuileries
Opening hours: Tue–Sat 11 am to 7 pm
Products: Optical glasses and sunglasses, beauty accessories, design and fashion goods
Special features: The modernity of this place which plays with transparency and mirror effects reveals the design and innovative spirit of the brand Face à Face

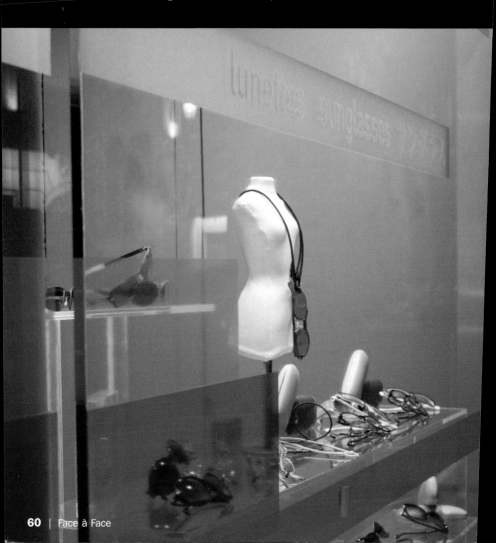

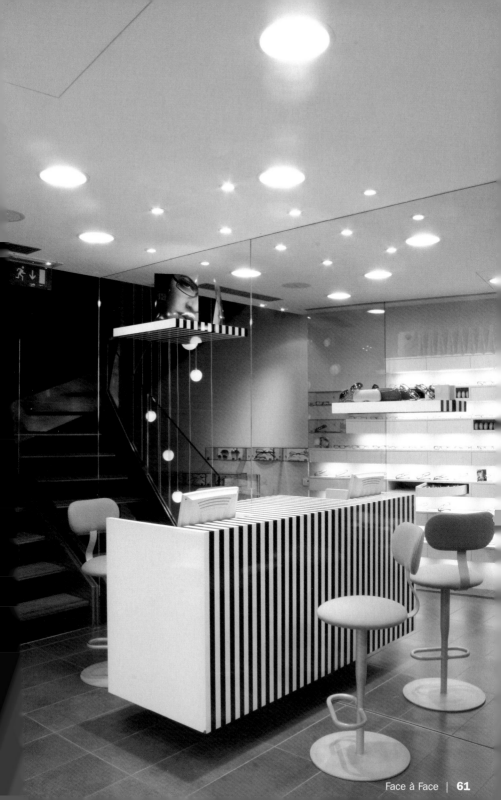

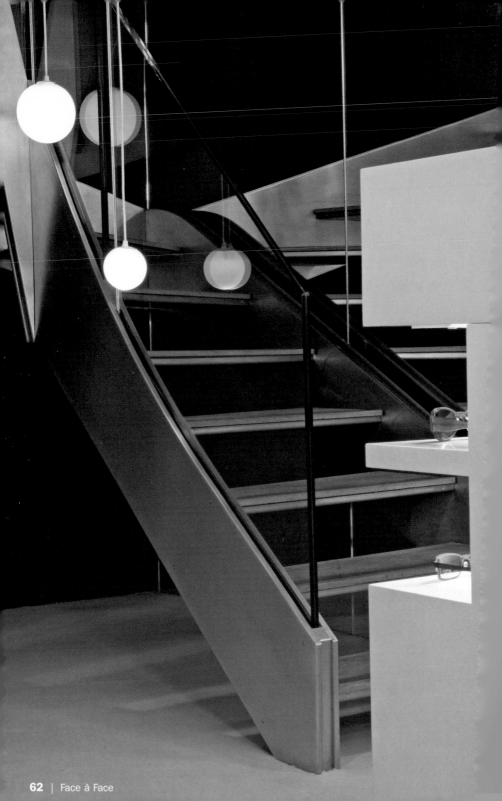

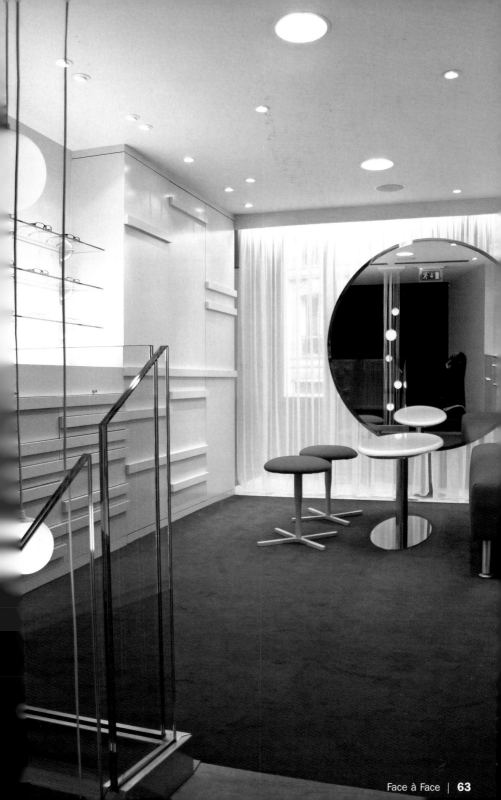

Fresh

Design: Marine Marchand

5, Rue du Cherche-Midi | 75006 Paris
Phone: +33 1 53 63 33 83
www.fresh.com
Subway: Saint-Sulpice, Sèvres-Babylone
Opening hours: Mon–Sat 10 am to 7 pm
Products: Luxury products for body care and house decoration
Special features: Modern and pure architecture where the products are enhanced

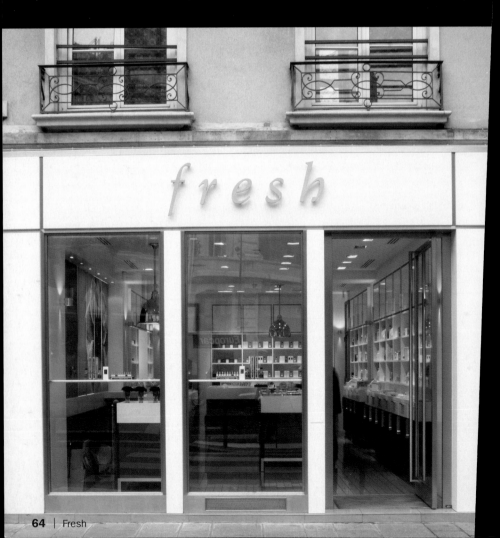

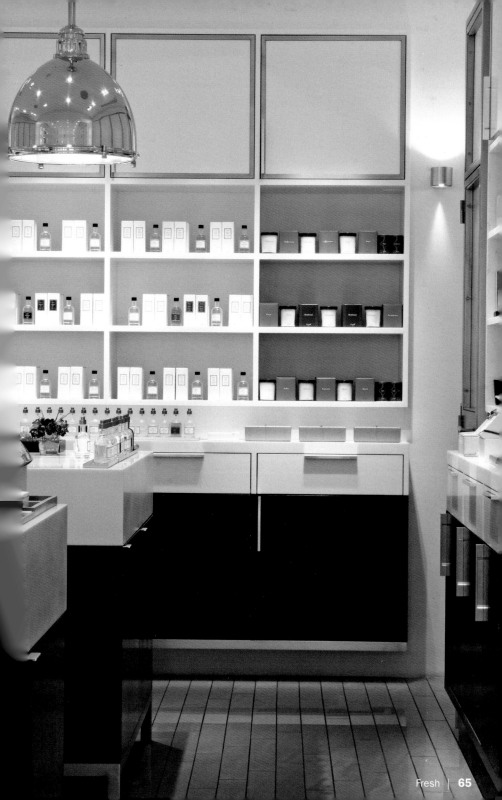

Galerie Dansk

Design: Donatienne Tiberghien

32, Rue Charlot | 75003 Paris
Phone: +33 1 42 71 45 95
Subway: Temple, République, Filles du Calvaire
Opening hours: Tue–Sat 2 pm to 7 pm
Products: Danish design
Special features: Original furniture editions created by Scandinavian architects
from 1950–1970

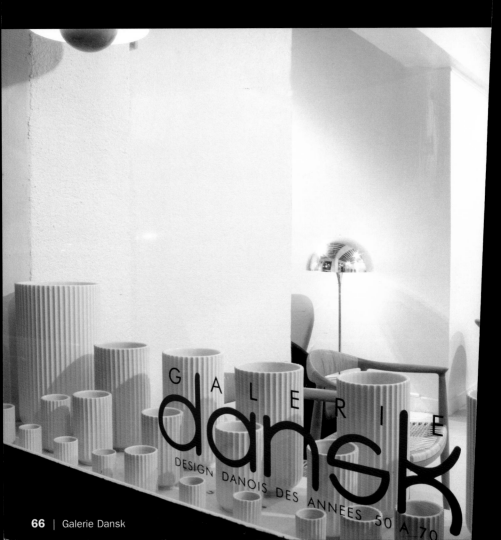

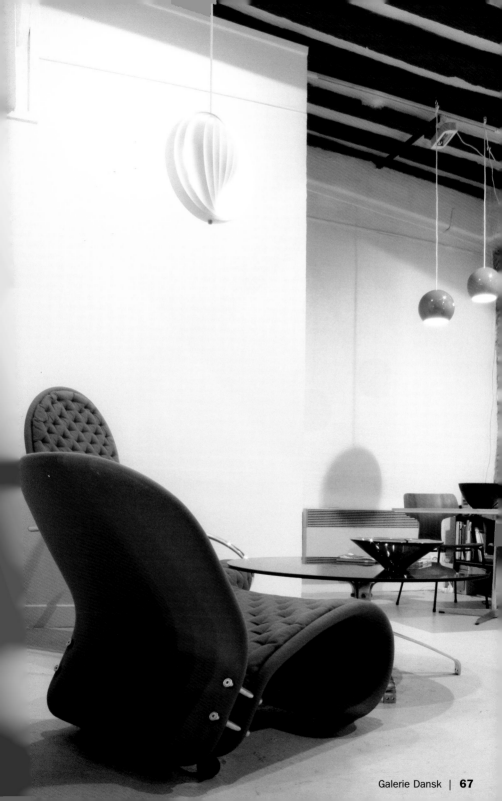

Galerie Kreo

Design: Combarel and Marrec

22, Rue Duchefdelaville | 75013 Paris
Phone: +33 1 53 60 18 42
www.galeriekreo.com
Subway: Chevaleret
Opening hours: Tue–Fri 2 pm to 7 pm, Sat 11 am to 7 pm
Products: Furniture and objects by contemporary designers internationally
well-known
Special features: Pieces in limited editions by Ronan & Erwan Bouroullec,
Marc Newson and Martin Szekely

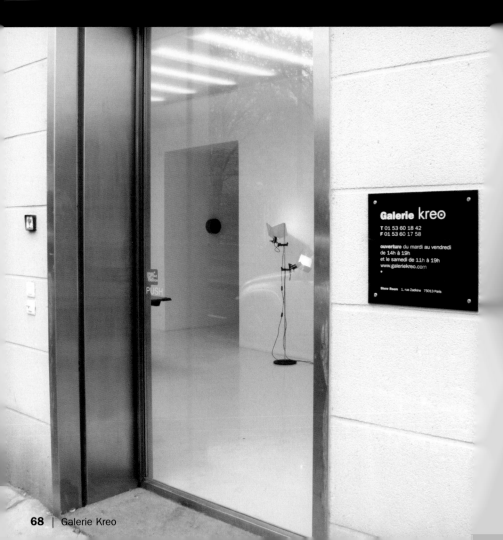

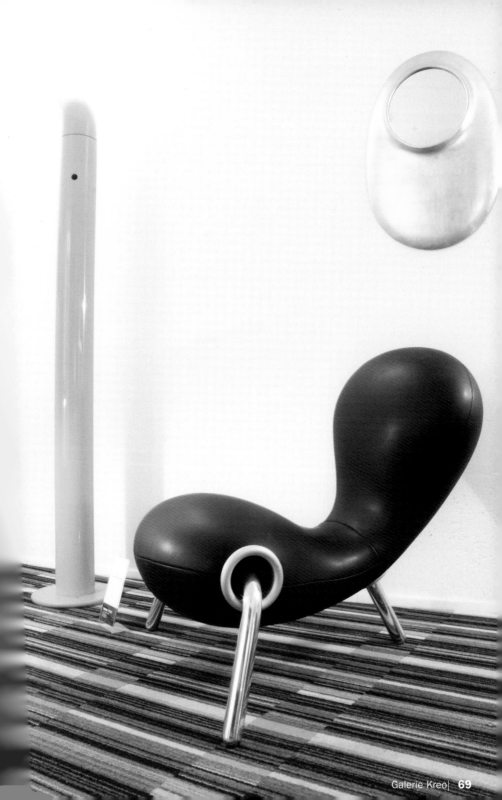

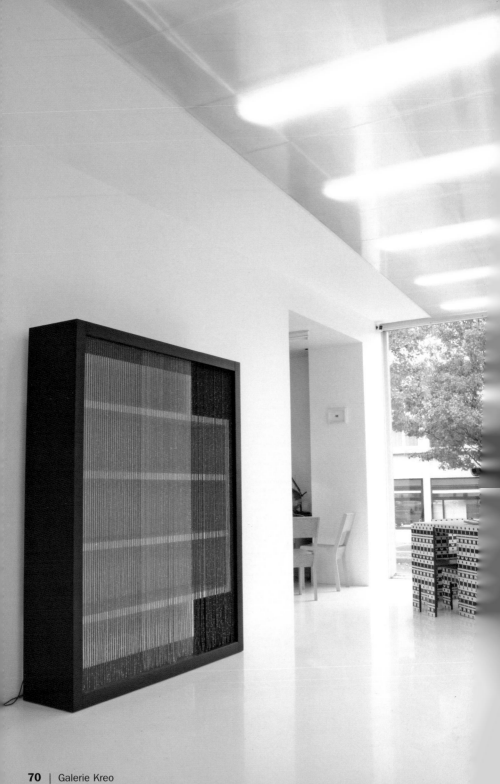

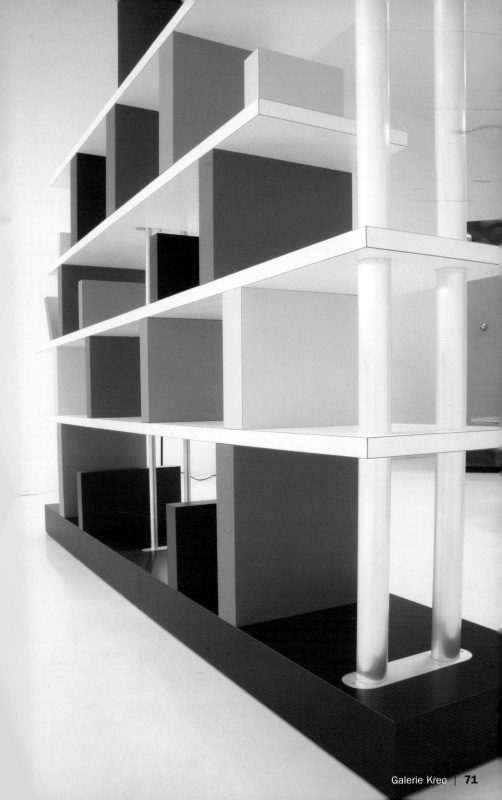

www.gucci.com
Subway: Franklin-D.-Roosevelt
Opening hours: Mon–Sat 10 am to 7 pm
Products: Accessories, small leather bags, timepieces, jewelry, eyewear
Special features: Luxury modern interior who respects the elegance of the original
building

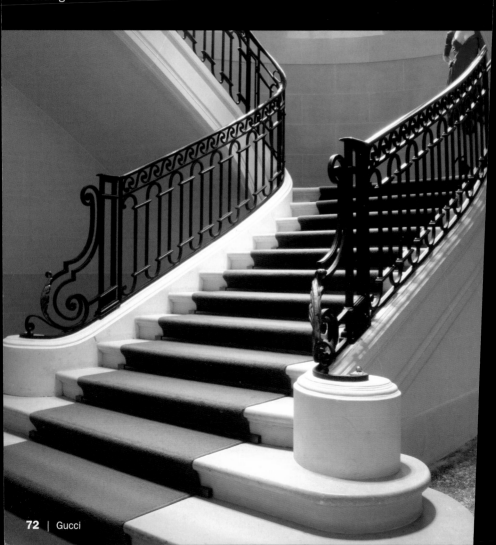

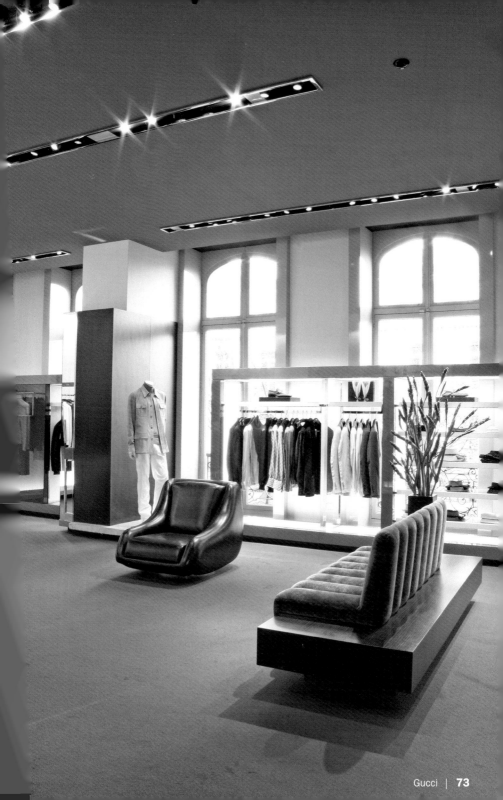

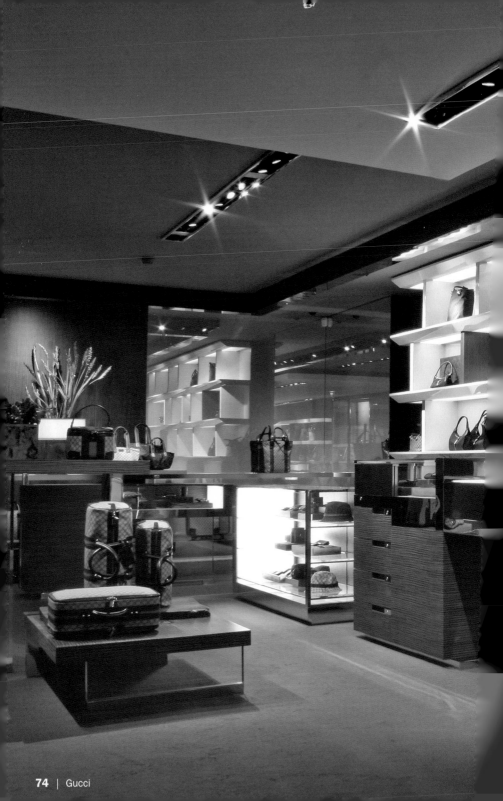

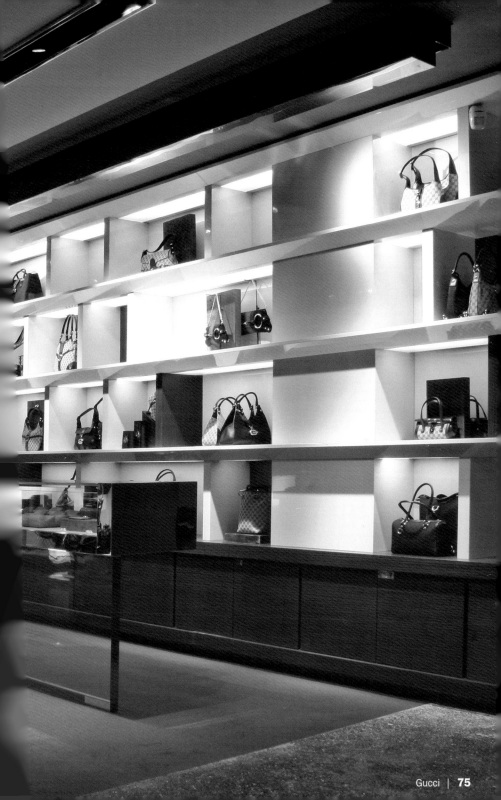

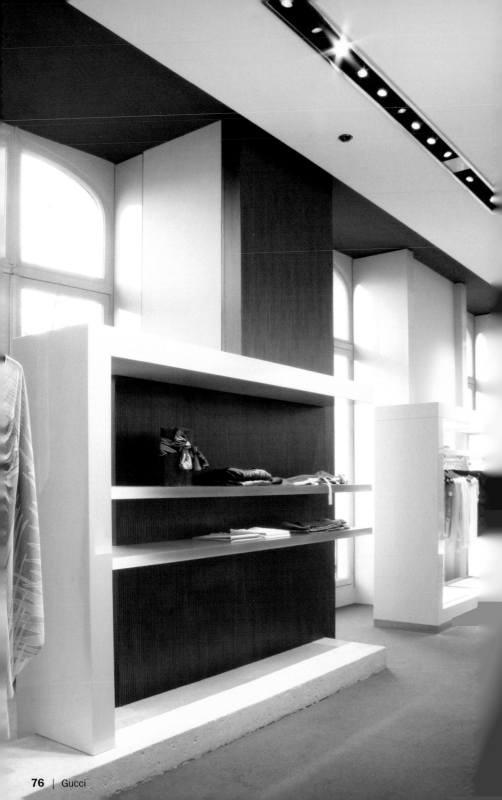

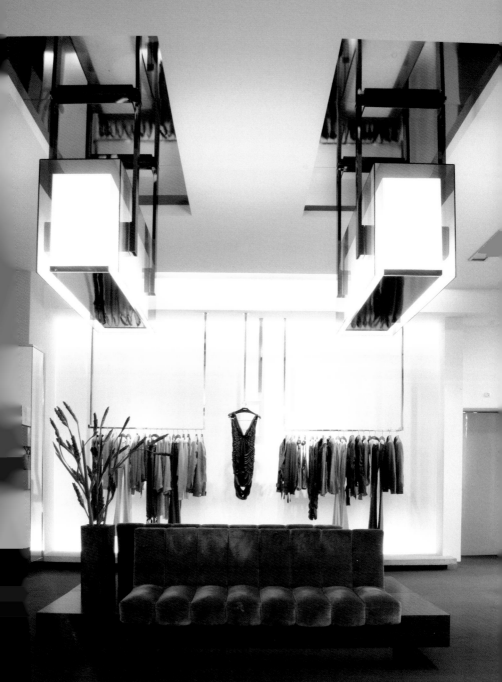

Jean-Paul Gaultier

Design: Philippe Starck

44, Avenue George V | 75008 Paris
Phone: +33 1 44 43 00 44
www.jeanpaul-gaultier.com
Subway: George V
Opening hours: Mon–Sat 10:30 am to 7 pm
Products: Prêt-à-porter
Special features: The universe of the fashion designer in a space

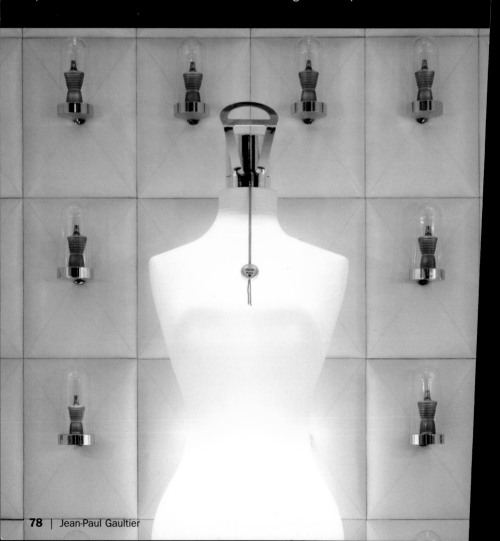

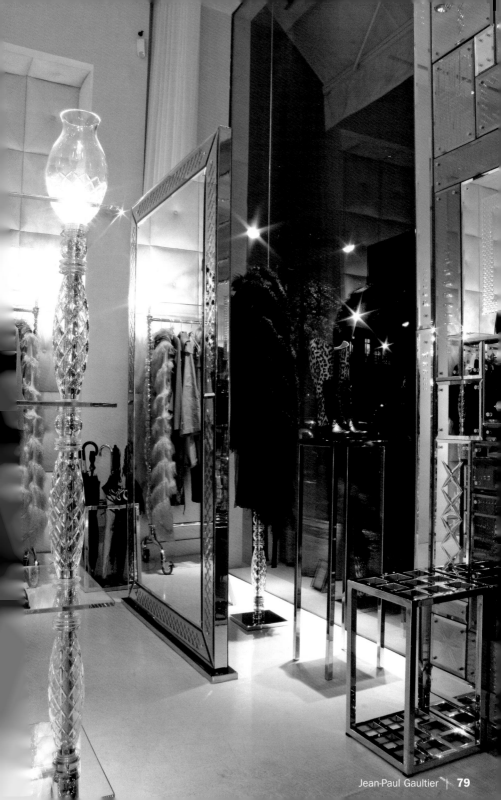

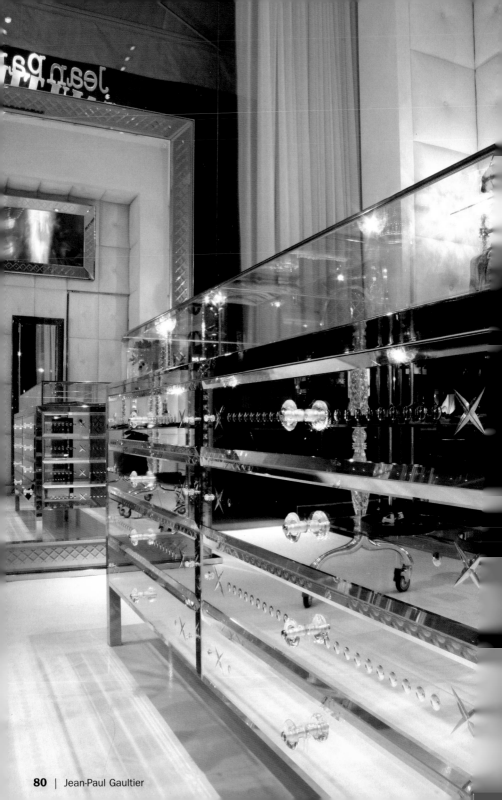

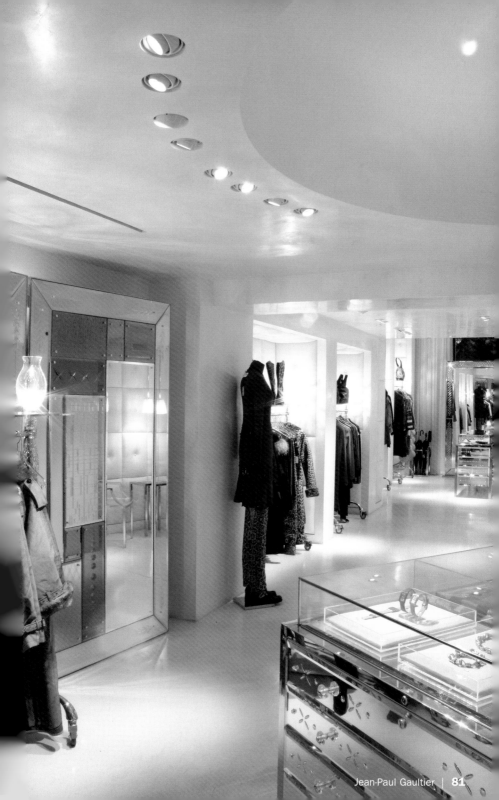

Jean-Paul Gaultier | 81

Knoll International

Design: Knoll

268, Boulevard Saint-Germain | 75007 Paris
Phone: +33 1 44 18 19 99
www.knoll.com
Subway: Solférino
Opening hours: Mon–Sat 10 am to 7 pm
Products: Furnishing by the best designers and architects
Special features: Designs of Florence Knoll

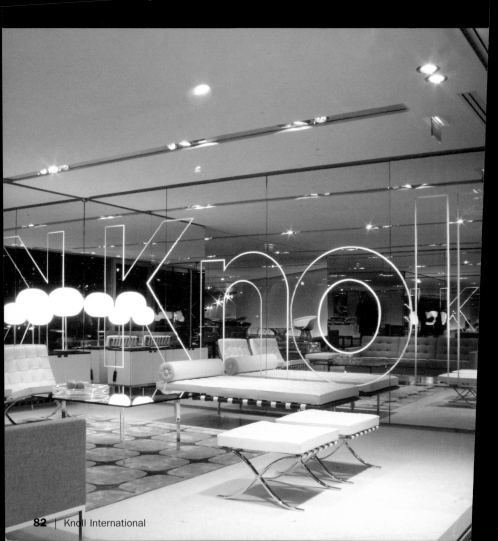

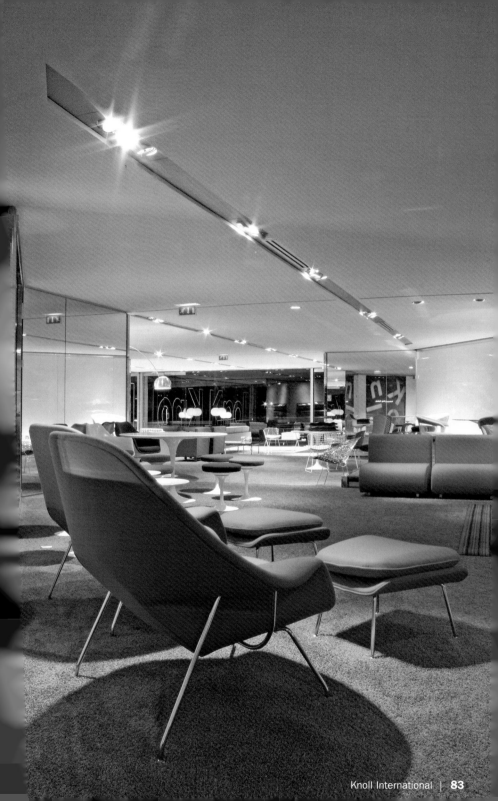

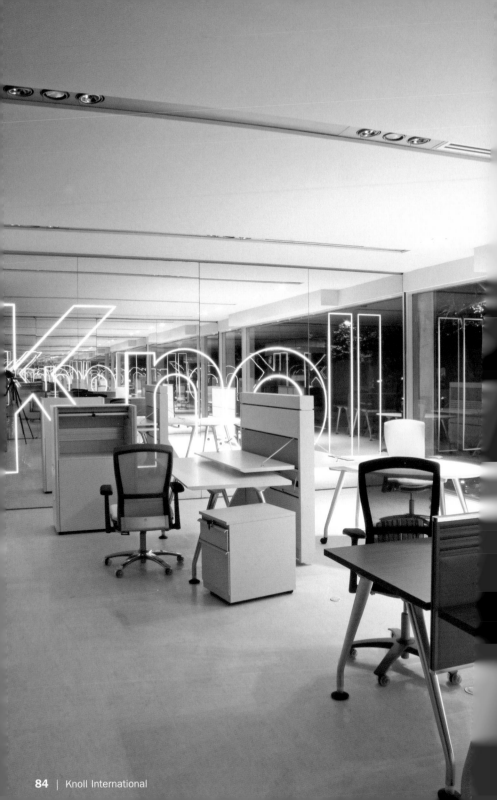

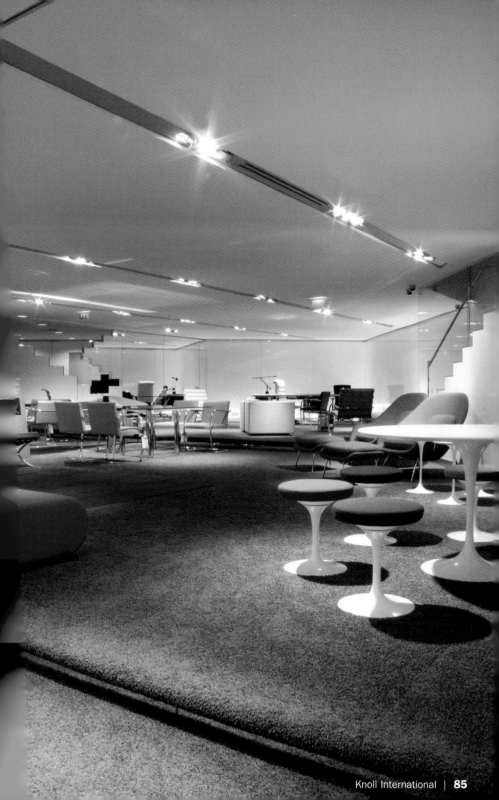

Kpochs by Jean-Michel Faretra

Design: Welonda

22, Rue des Capucines | 75002 Paris
Phone: +33 1 42 86 11 23
Subway: Opera, Madeleine
Opening hours: Tue–Wed and Fri–Sat 10 am to 6:30 pm, Thu 10 am to 9:30 pm
Products: Best products for hair care
Special features: A futuristic concept-space with the best equipment

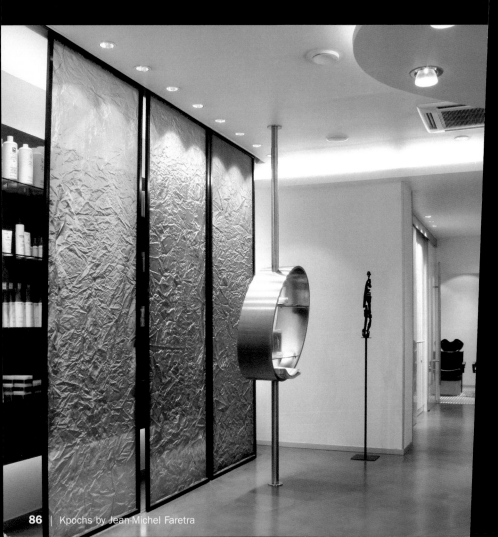

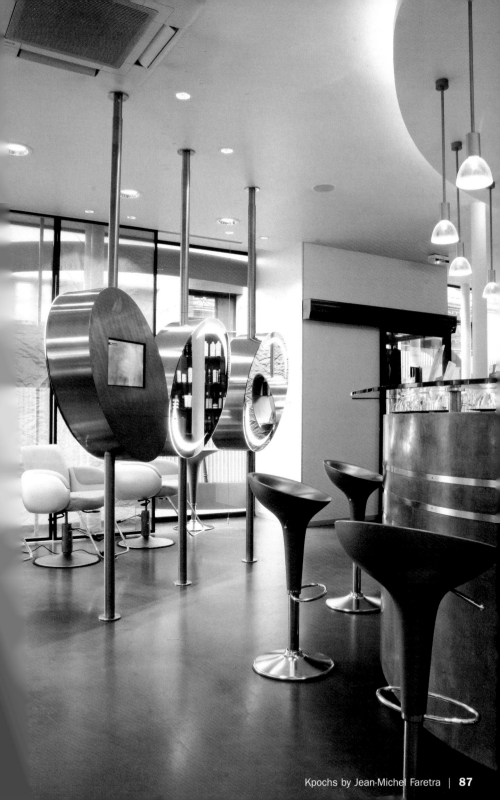

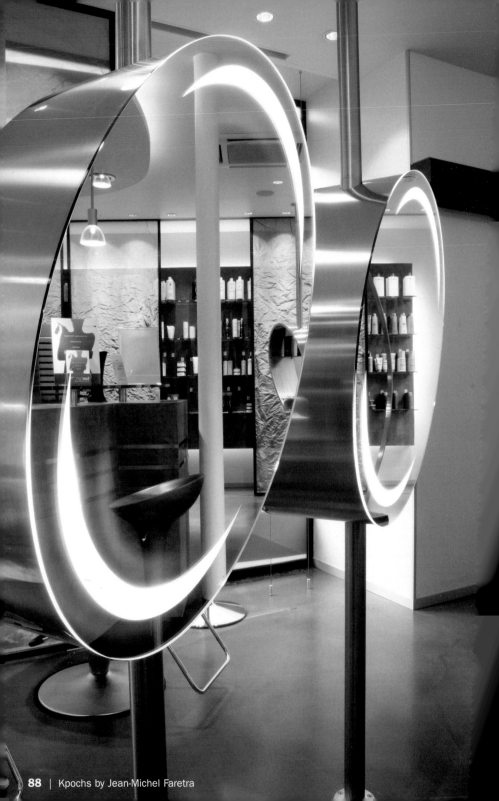

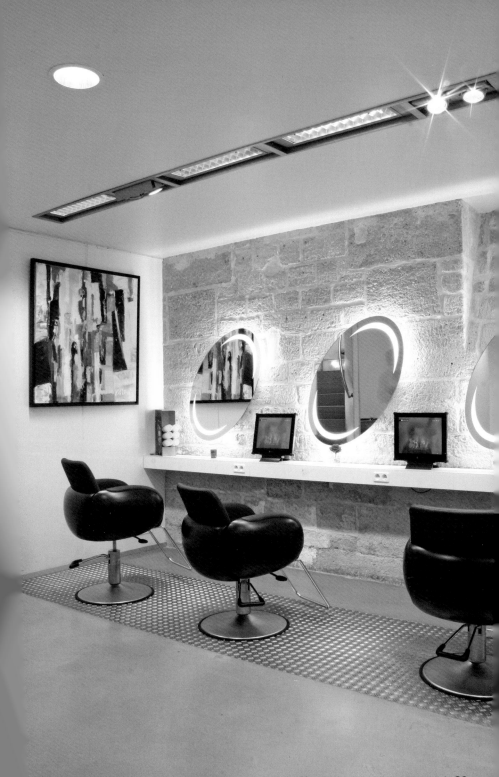

L'Atelier du Savon

Design: Lecaron Architecte and Marco Scarani

29, Rue Vieille-du-Temple | 75004 Paris
Phone: +33 1 44 54 06 10
www.savonparis.com
Subway: Hôtel-de-Ville, Saint-Paul
Opening hours: Mon–Sat, April to October 11:30 am to 7:30 pm, November to
March 12 am to 8 pm
Products: Soaps of different shapes and scents
Special features: White marble, concrete ground and grey walls which make a
contrast with the great variety of colors of the products

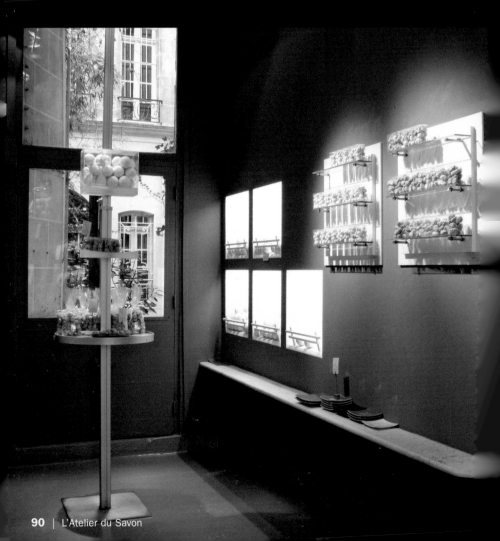

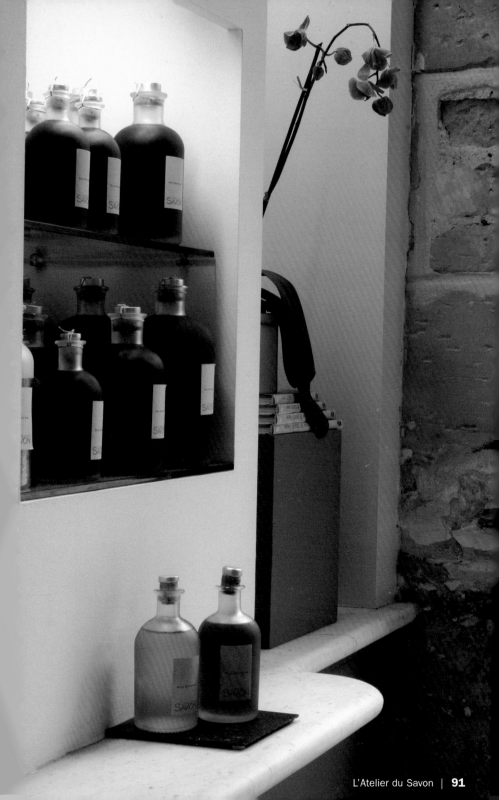

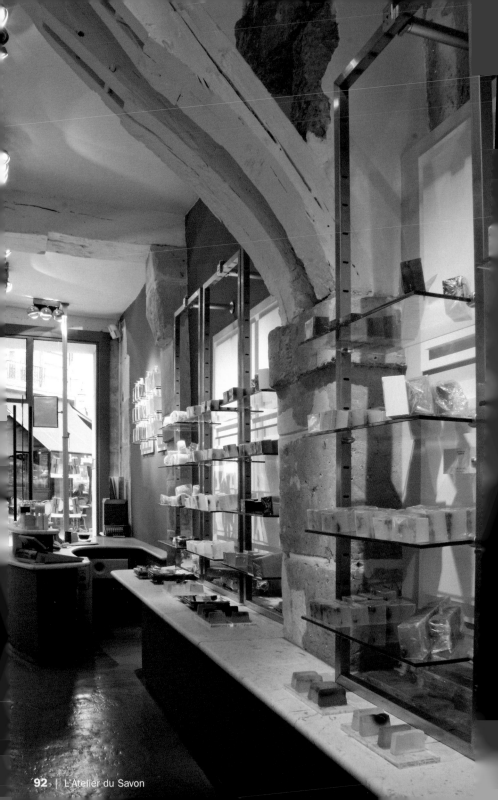

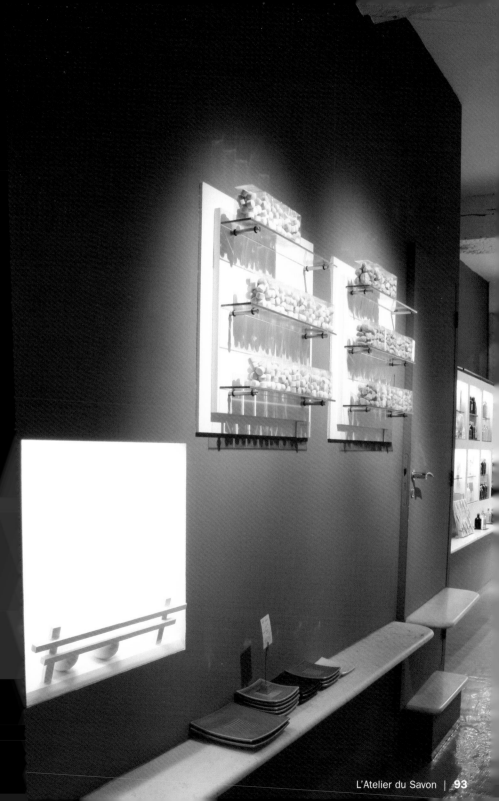

Les Salons du Palais Royal Shiseido

Design: Serge Lutens

142, Galerie de Valois – 25, Rue de Valois, Jardins du Palais Royal | 75001 Paris
Phone: +33 1 49 27 09 09
www.salons-shiseido.com
Subway: Palais-Royal
Opening hours: Mon–Sat 10 am to 7 pm
Products: Parfums and other beauty goods
Special features: A Paris classic, sophisticated and sumptuous

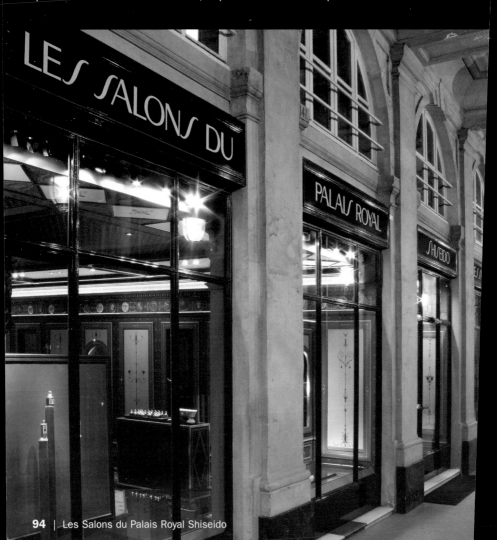

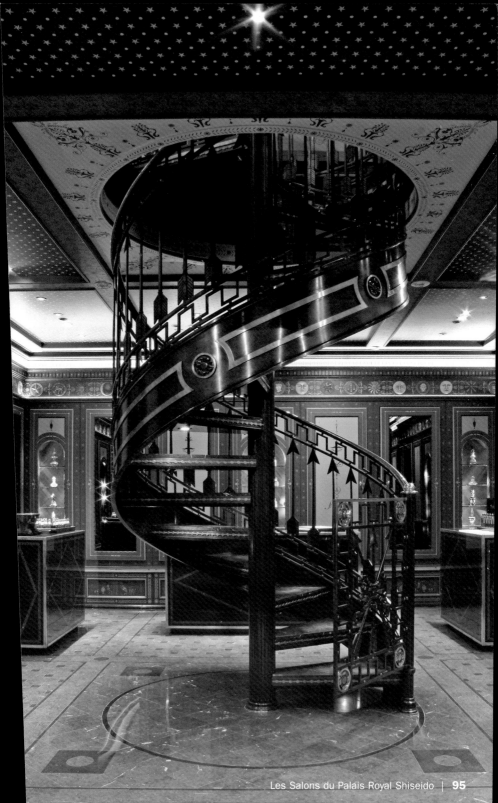

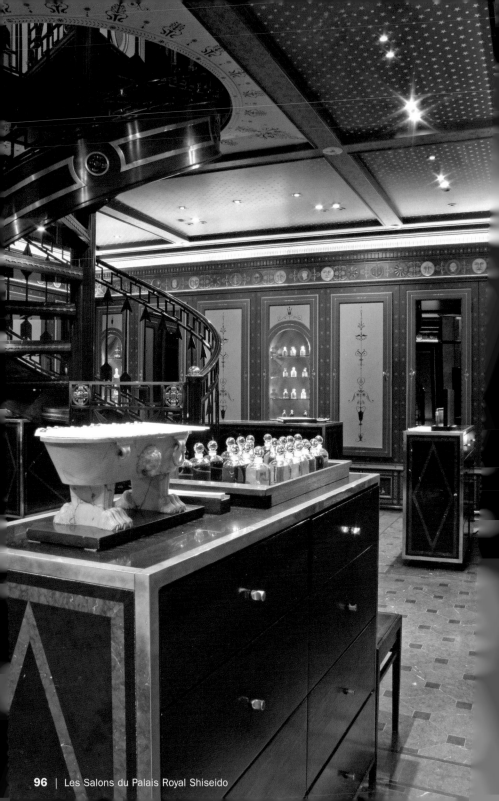

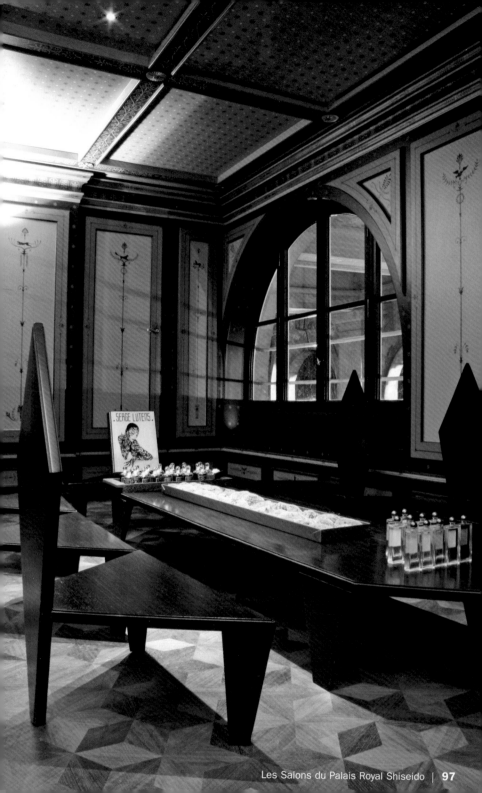

Louis Vuitton

Design: Peter Marino

54, Avenue Montaigne | 75008 Paris
Phone: +33 1 45 62 47 00
www.vuitton.com
Subway: Franklin-D.-Roosevelt, Alma-Marceau
Opening hours: Mon–Sat 9:30 am to 7 pm
Products: Clothes and accessories
Special features: Represents the wholeness of Louis Vuitton collections

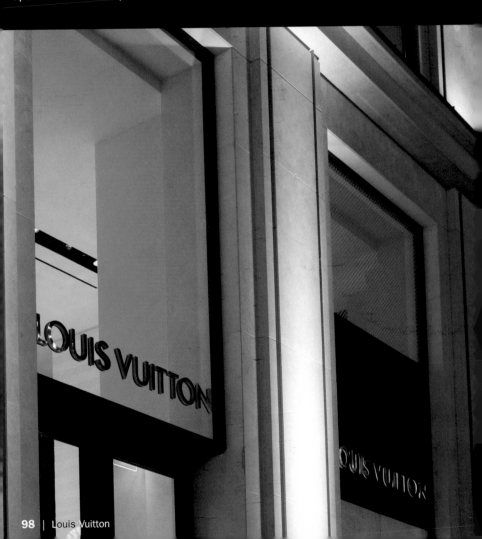

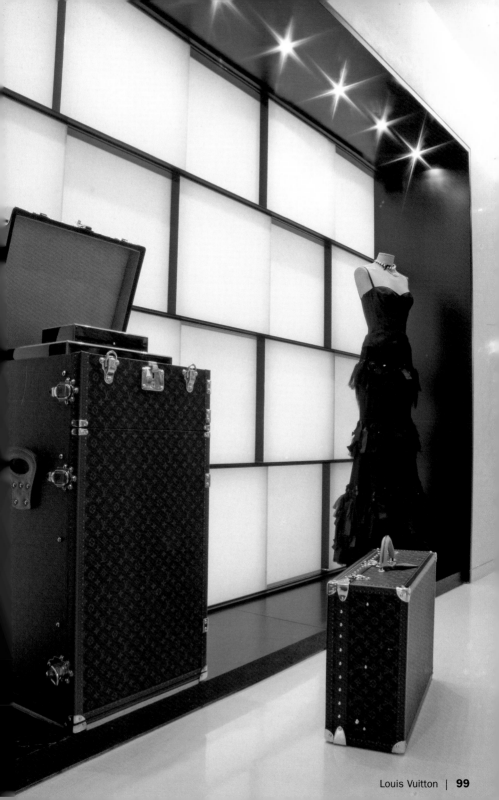

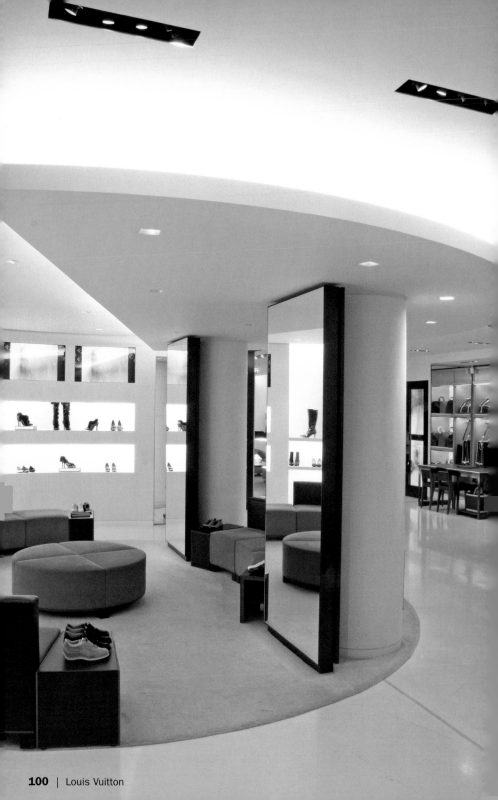

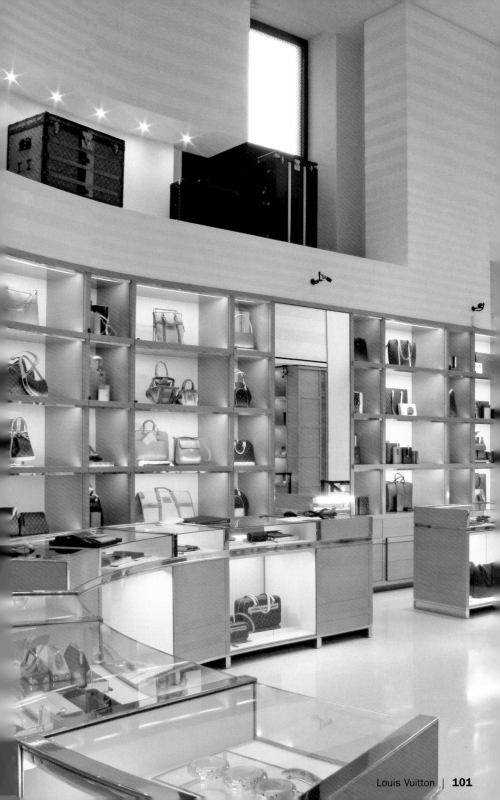

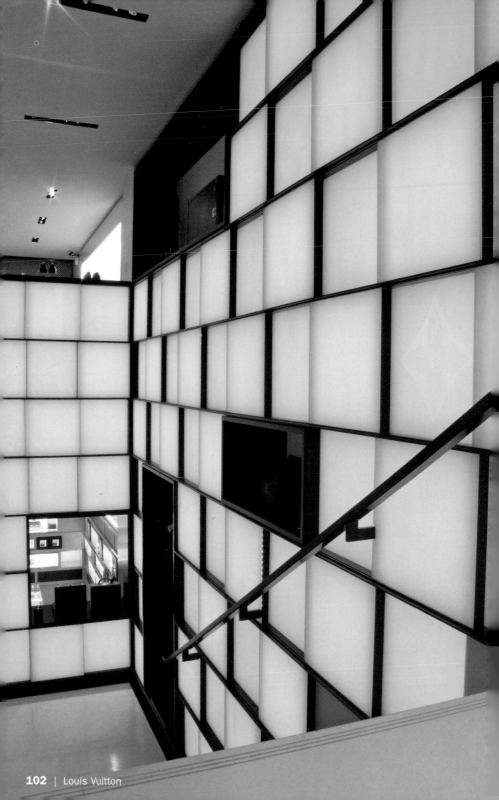

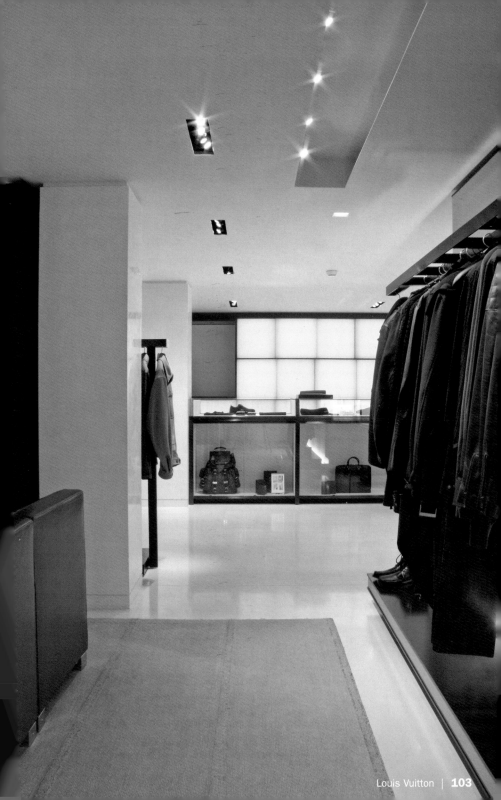

Mandarina Duck

Design: Studio x design group

36, Rue Étienne-Marcel | 75002 Paris
Phone: +33 1 40 13 02 96
www.mandarinaduck.com
Subway: Étienne Marcel, Louvre
Opening hours: Mon–Sat 11 am to 7 pm
Products: Leather goods, handbags
Special features: The furnishing design reflects the style of this famous urban bags

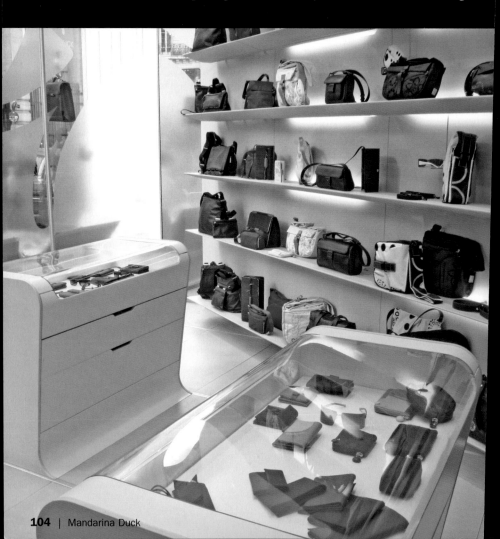

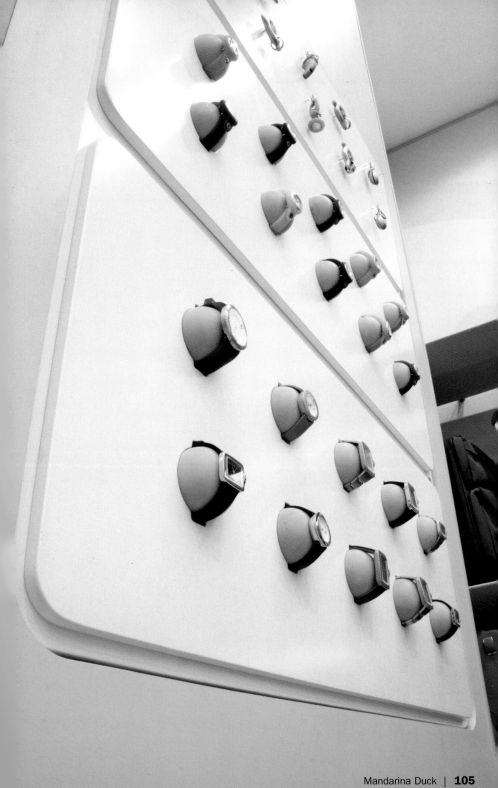

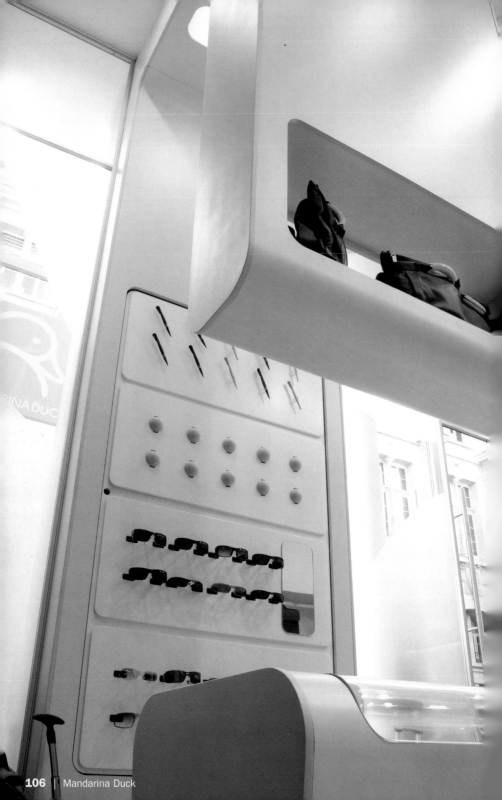

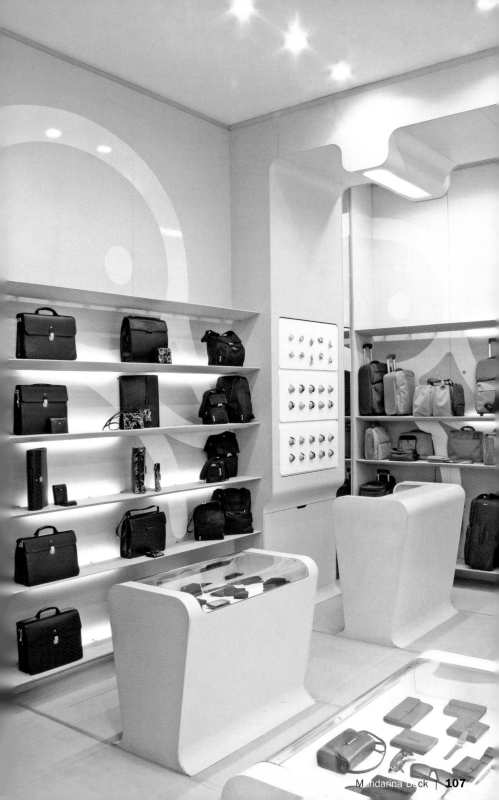

Subway: Concorde
Opening hours: Mon–Sat 10:30 am to 7 pm
Products: Feminine shoes
Special features: A theatrical environment with high-heeled shoes displayed on satin cousins

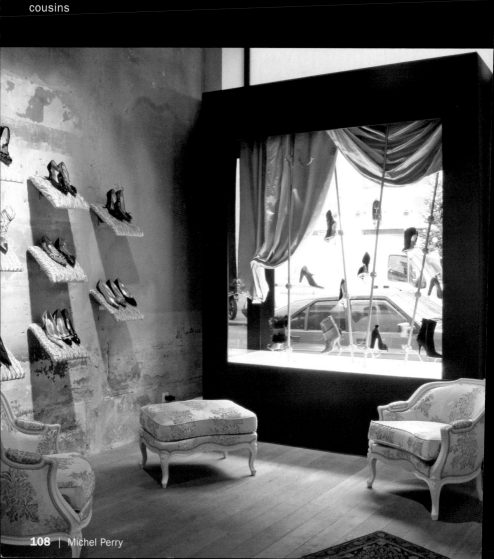

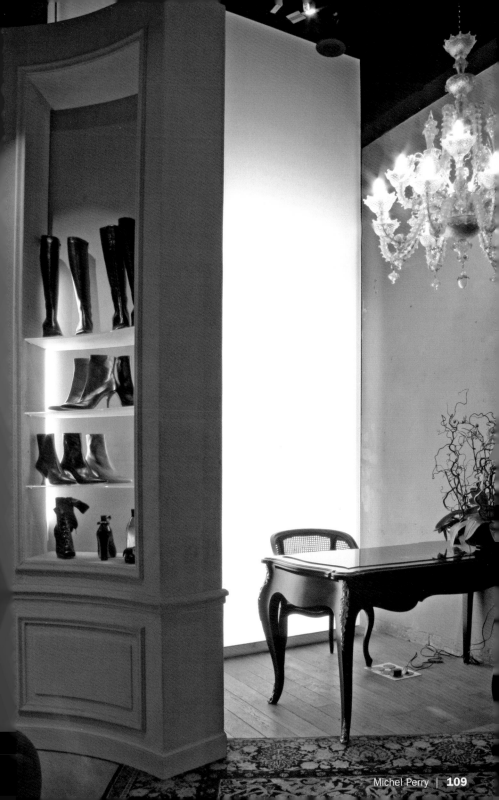

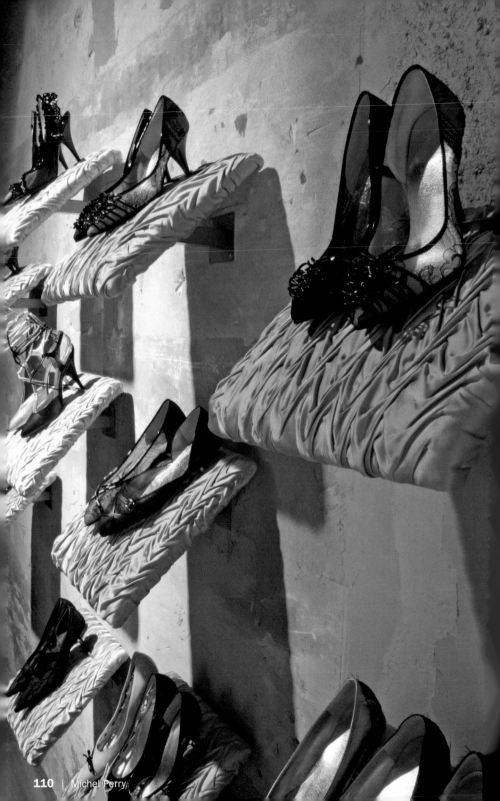

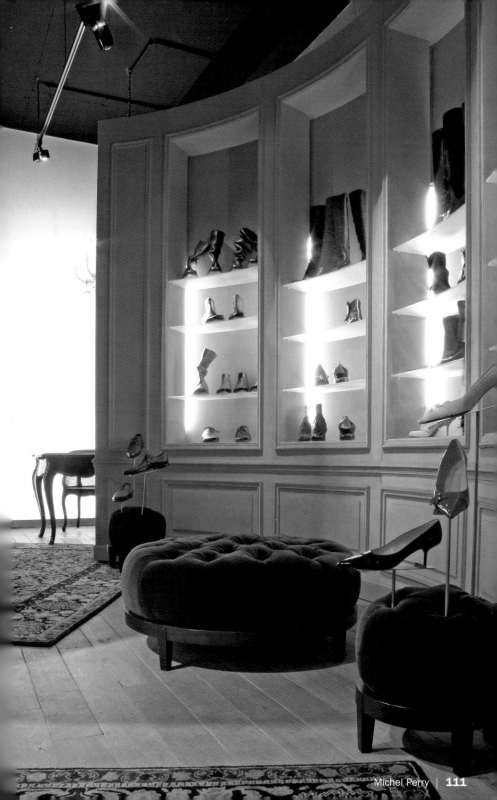

Orizzonti

Design: Paola Navone

28, Rue d'Assas | 75008 Paris
Phone: +33 1 42 22 43 35
www.arenafurniture.com
Subway: Rennes
Opening hours: Tue–Sat 10:30 am to 7 pm
Products: Bedroom furniture
Special features: Specialized in night atmospheres

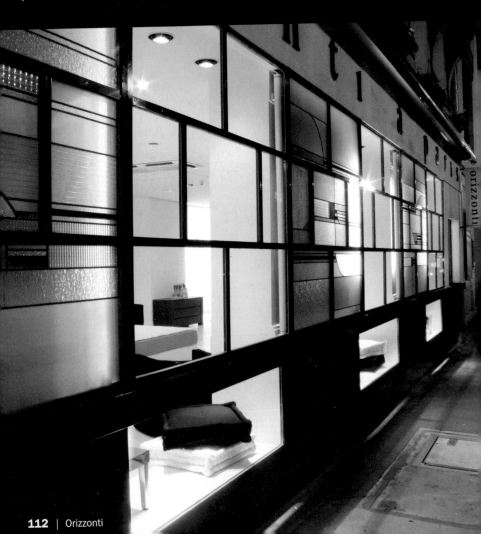

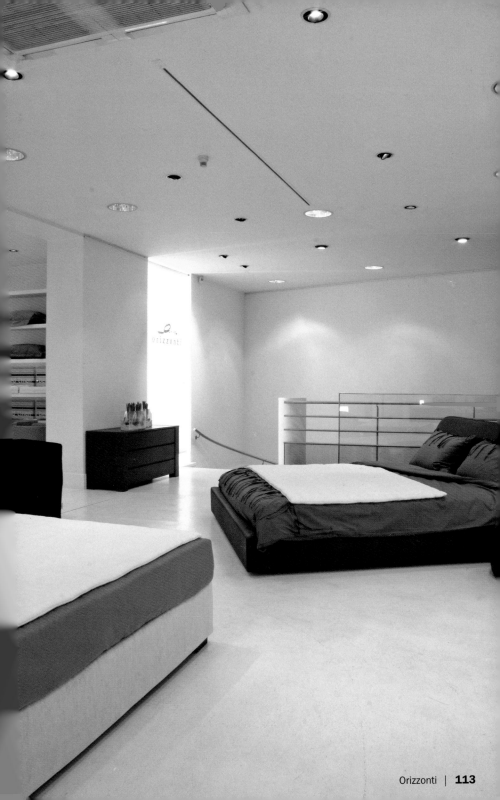

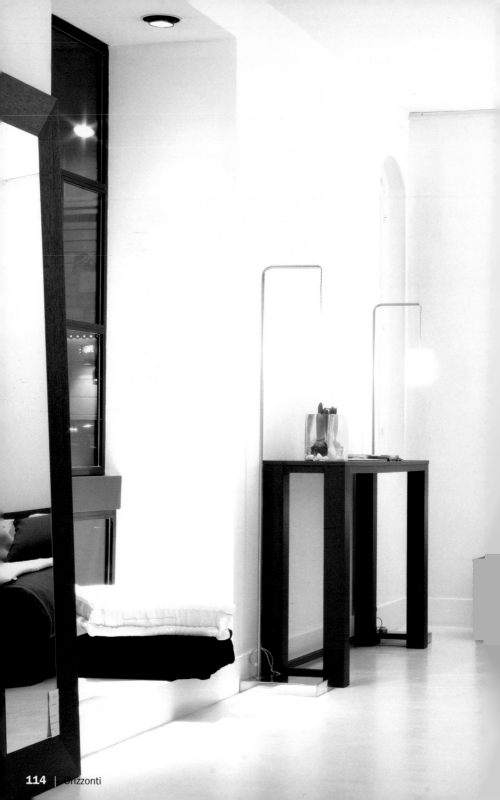

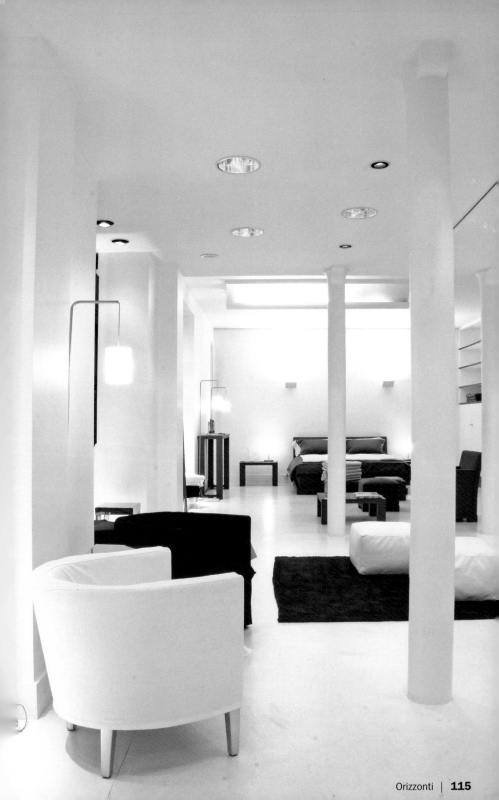

Peugeot Avenue

Design: Saguez & Partners and Versions

136, Avenue des Champs-Elysées | 75008 Paris
Phone: +33 1 42 89 30 20
ww.peugeot.com
Subway: Charles de Gaulle-Etoile, Georges V
Opening hours: Sun–Wed 10:30 am to 8 pm
Products: The articles sold in the boutique reflect the values of the brand, such as
innovation, dynamism, blue chips and design
Special features: Peugeot Avenue brings together vehicles from the past, the present
and the future

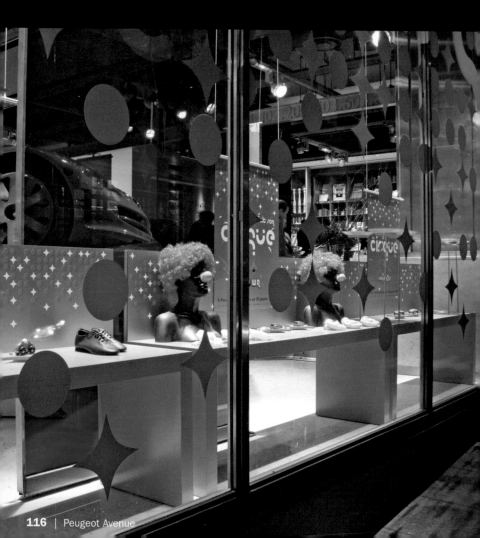

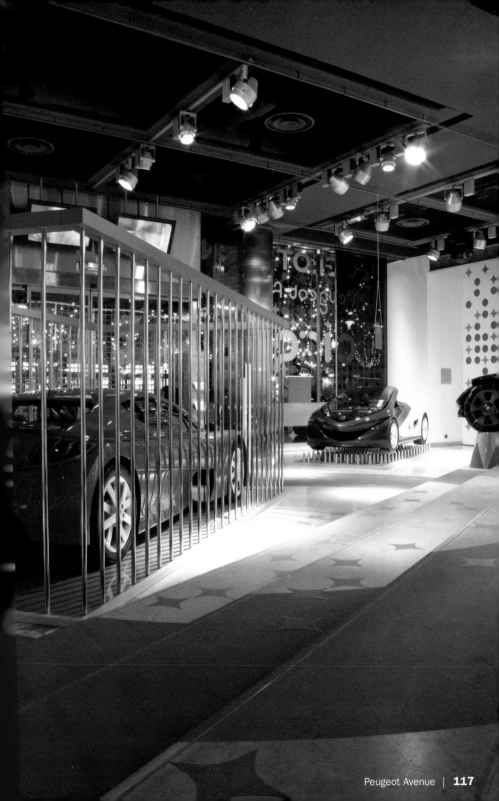

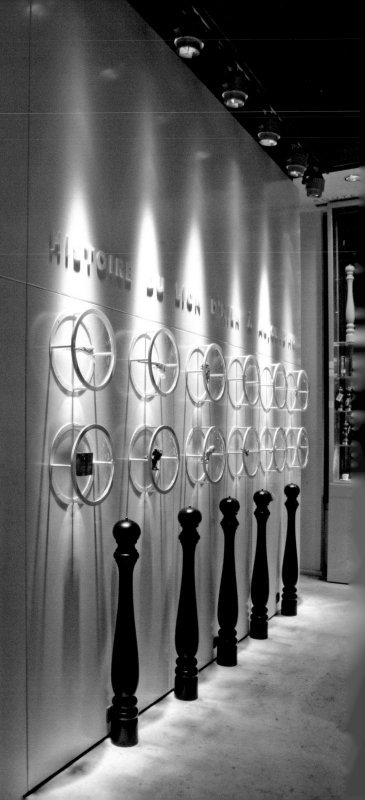

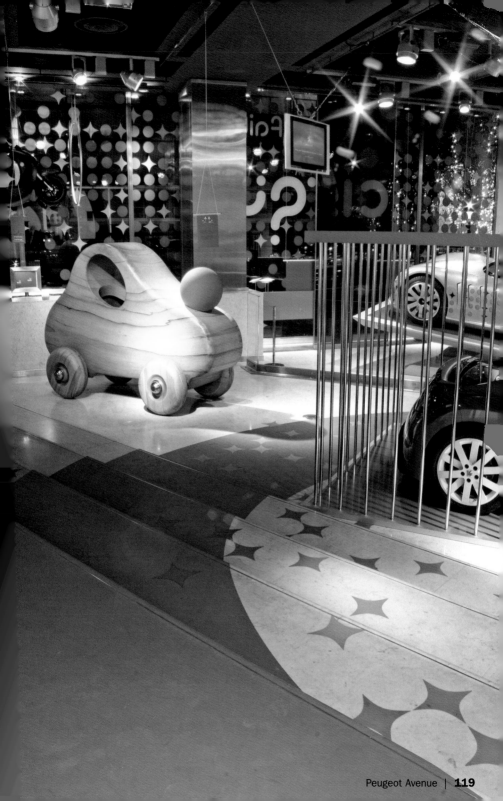

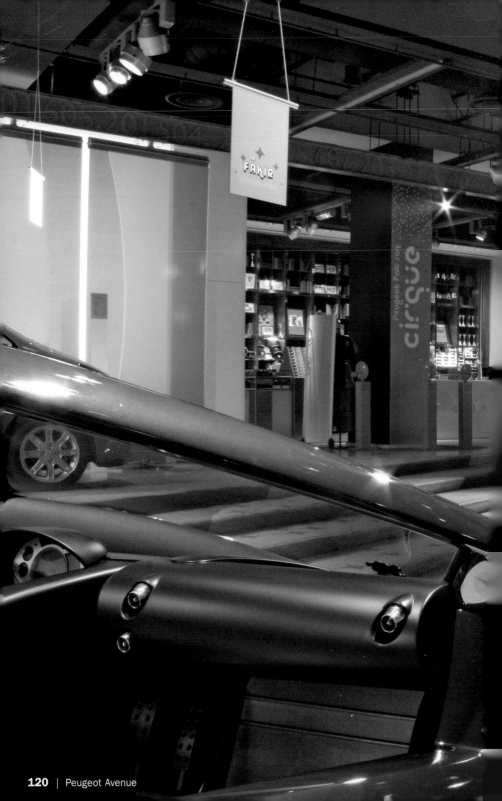

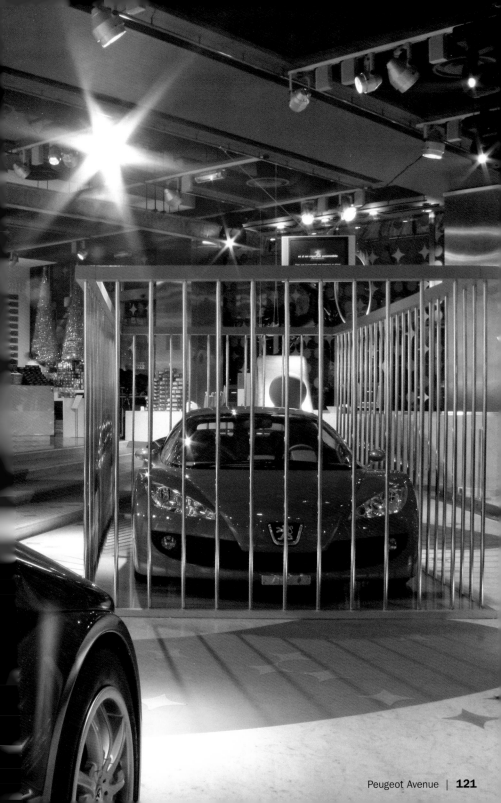

Pierre Herme

Design: Christian Biecher

185, Rue de Vaugirard | 75015 Paris
Phone: +33 1 47 83 89 96
Subway: Pasteur
Opening hours: Tue–Sat 10 am to 7 pm, Sun 10 am to 7:30 pm
Products: High-design cakes and pastries
Special features: Taste, sensation and pleasure in a clear space

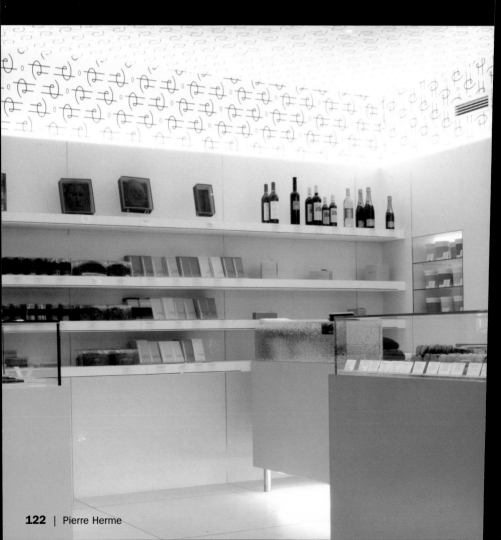

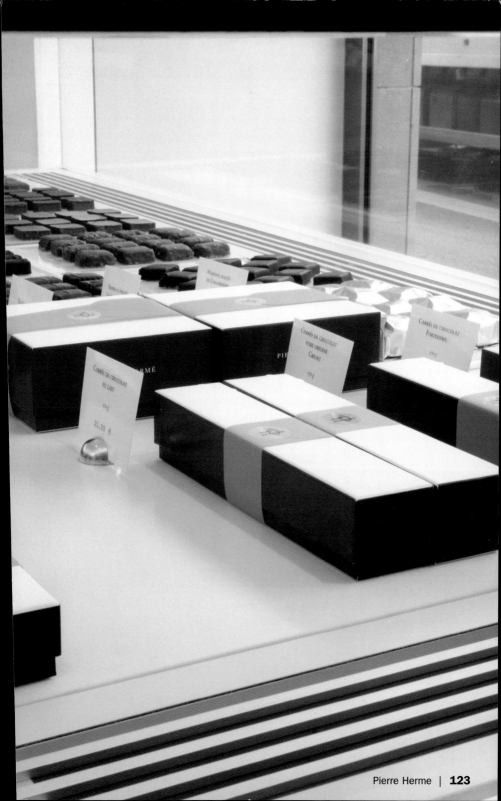

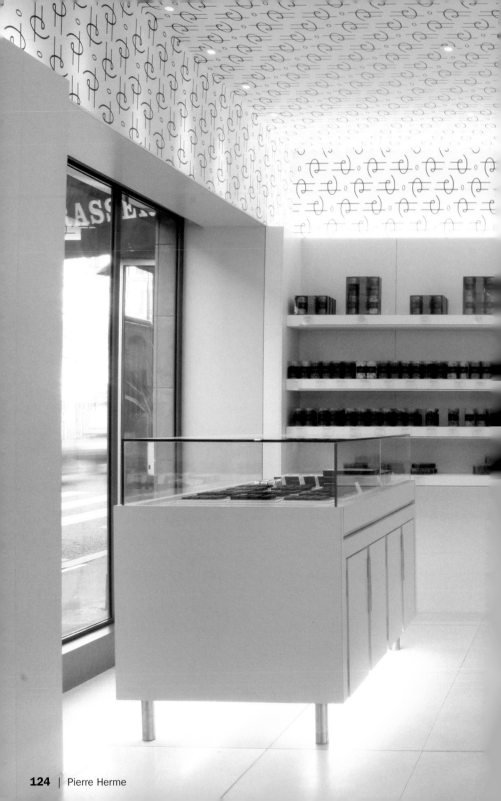

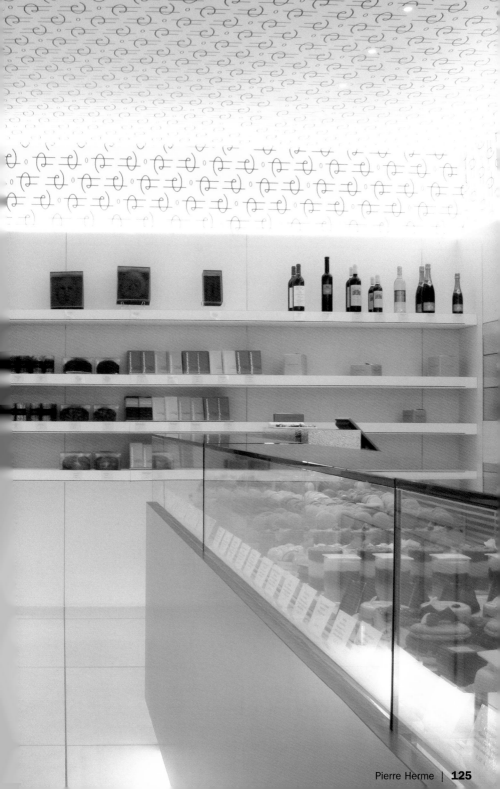

Van der Bauwede

Design: Roland Delen and Ars Spatium

16, Rue de la Paix | 75002 Paris
Phone: +33 1 42 60 48 48
www.vanderbauwede.ch
Subway: Opéra
Opening hours: Mon–Sat 10 am to 6 pm
Products: Distinctive watches, exclusive brand
Special features: Invitation to serenity, dreaming and beauty in a consistent
environment

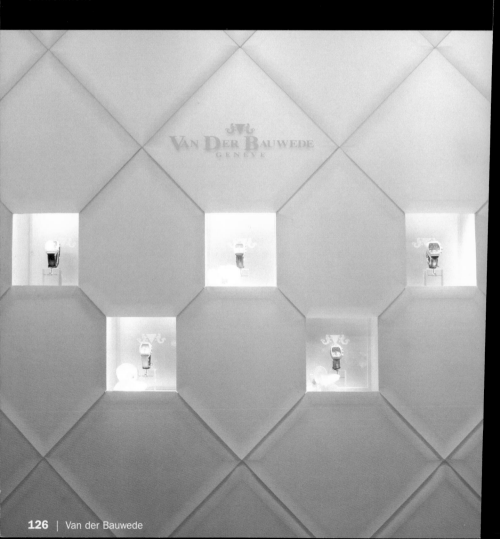

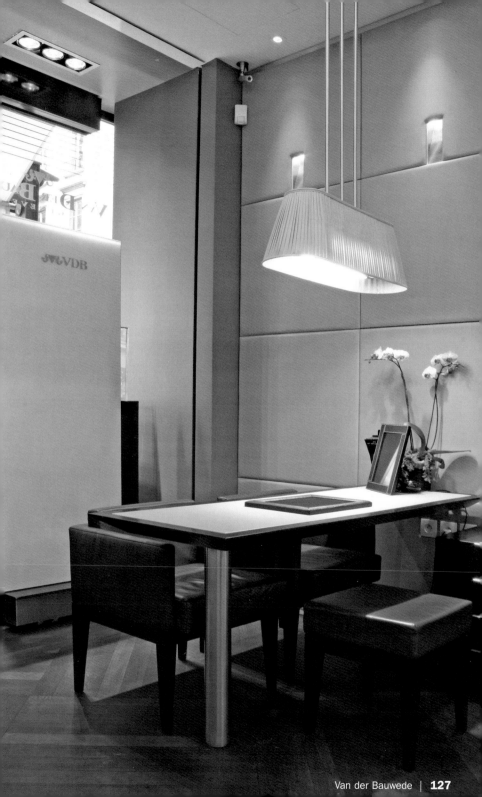

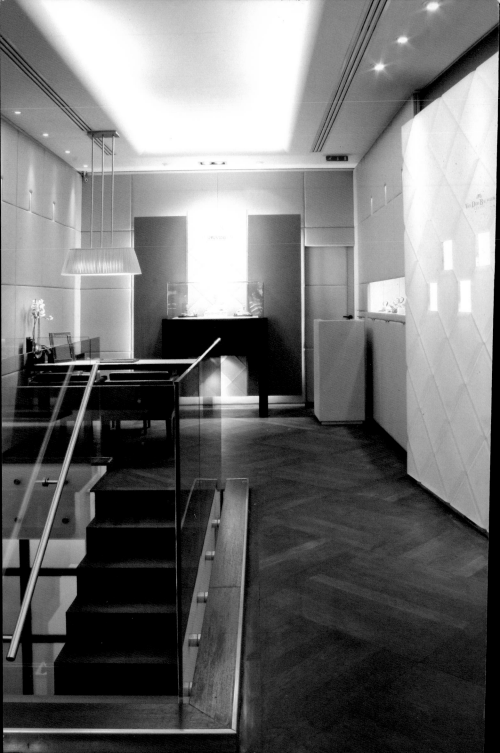

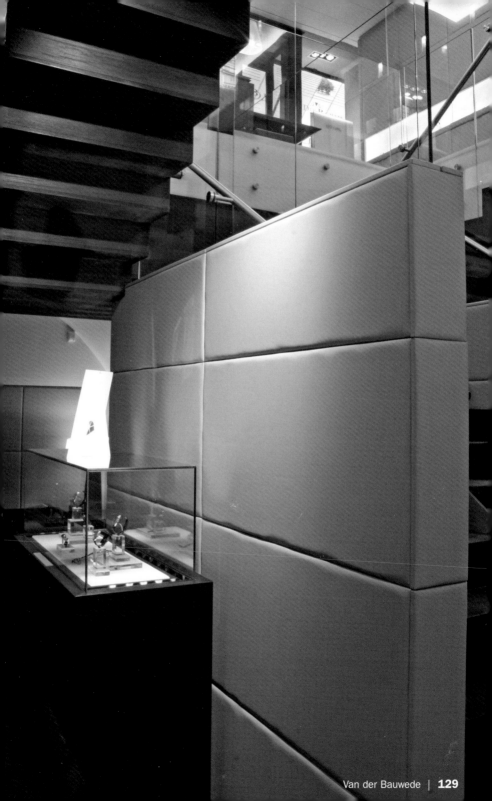

Zero one one

Design: Christophe Pillet

2, Rue de Marengo | 75001 Paris
Phone: +33 1 49 27 00 11
www.zerooneone.com
Subway: Louvre, Palais-Royal
Opening hours: Tue–Sat 11 am to 7:15 pm
Products: Equipment for all the spaces of the house
Special features: Luxurious and contemporary design

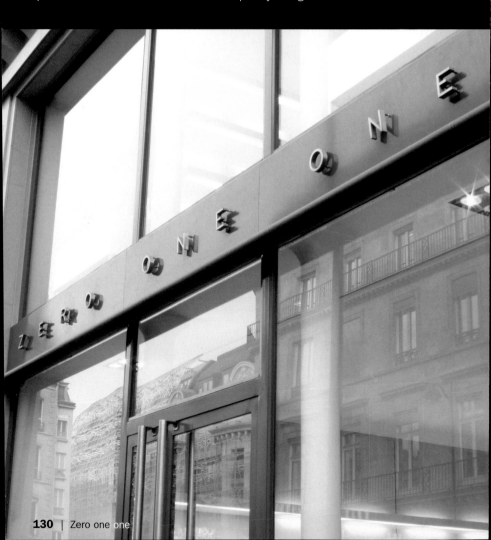

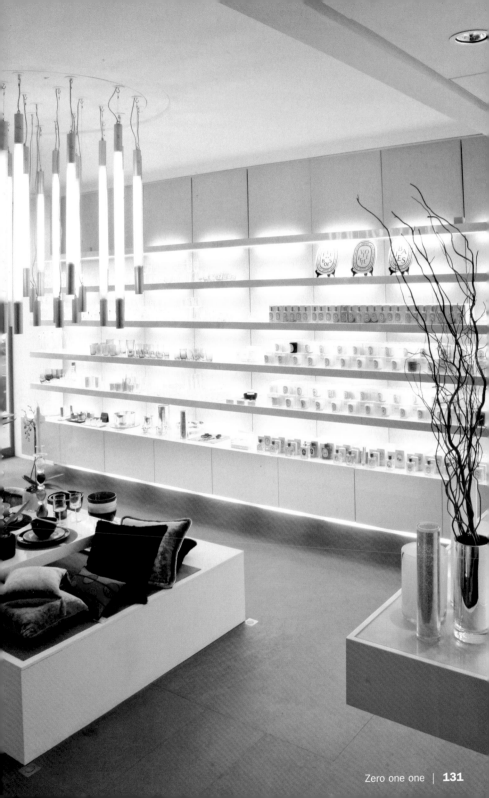

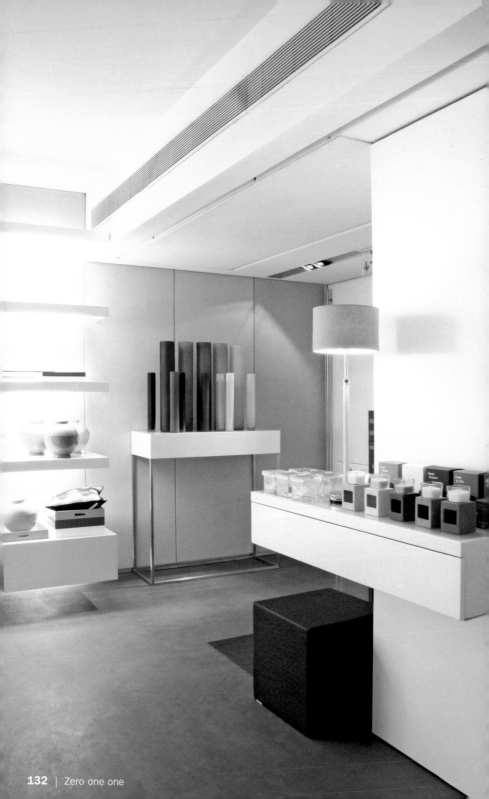

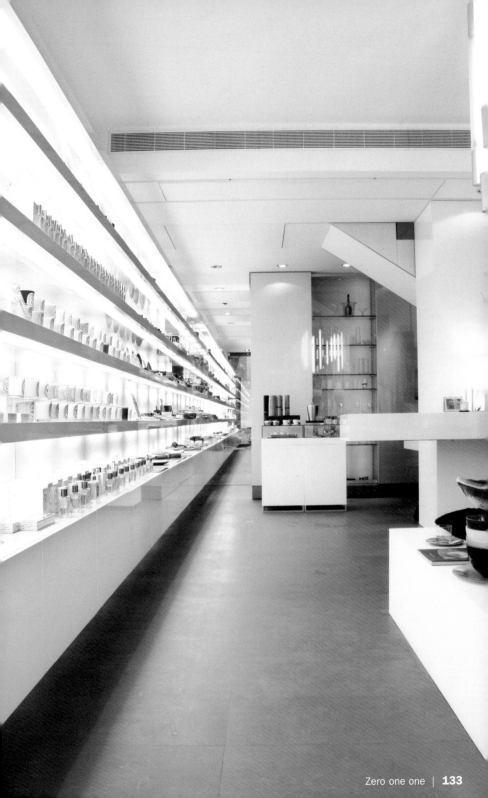

Seine

Avenue Charles de Gaulle

Bois de Boulogne

Arc de Triomphe 27

18 Avenue des

Avenue Victor Hugo

Avenue Kléber

12
23
17

Tour Eiffel

ST. GERMA
DES PRÉ

AUTEUIL

Seine

28

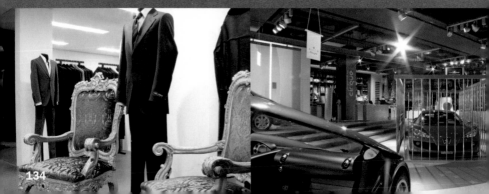

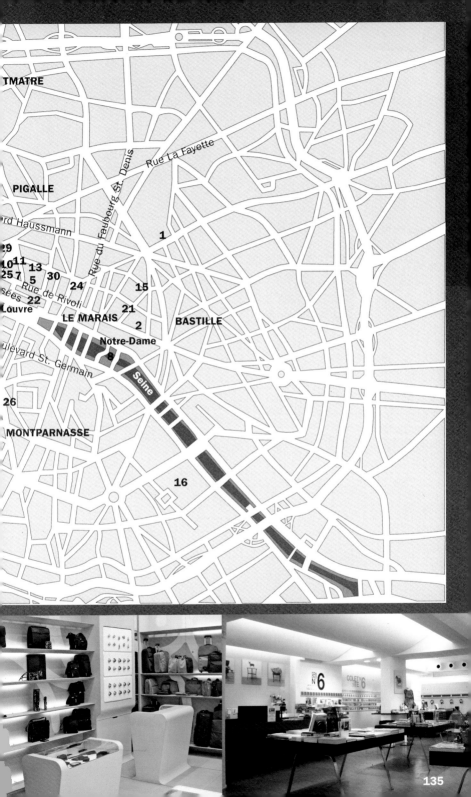

Published in the same series:

ISBN 3-8327-9038-1

ISBN 3-8327-9022-5

ISBN 3-8327-9021-7

COOL SHOPS

Size: 14 x 21.5 cm / 5½ x 8 in.
136 pp
Flexicover
c. 100 color photographs
Text in English, German, French,
Spanish and Italian

To be published in the same series:

Barcelona
Berlin
Hamburg
Hong Kong
Los Angeles
Madrid
Munich
Tokyo

teNeues